The College History Series

GEORGETOWN
UNIVERSITY

This Indenture made this twenty third day of January in the Year of Our Lord One thousand Seven Hundred and Eighty Nine Between William Deakins Junr and John Threlkeld of Montgomery County in the State of Maryland of the one Part and John Carroll Robert Moylneux and John Ashton of the other part Witnesseth that they the said William Deakins Junr and John Threlkeld for and in Consideration of the Sum of Seventy Five Pounds Currant Money to them in hand paid the Receipt thereof is hereby Acknowledged hath given Granted Bargained and Sold Aliened and Confirmed unto them the said John Carroll Robert Moylneux and John Ashton their Heirs and Assigns forever all that Lott or Portion of Ground Beginning at a Stone Marked No One Standing in a line drawn Westwardly from the North Side of the first Street of Peter Beatty Deakins and Threlkelds Addition to George Town and at the end of a line drawn South thirty five Degrees East Ninety One feet from the South East corner of the Colledge now Building and Running thence Westwardly two hundred and ten feet to a Stone No two thence North three hundred and Seventy feet to a Stone No three East two hundred and ten feet to a Stone No four South three Hundred and Seventy feet to the Beginning containing One Acre and a half of an Acre more or less Together with all the Improvements and Advantages thereunto belonging to have and to hold the aforesaid Lott or Portion of Ground and Premises with its Appurtenances unto them the said John Carroll Robert Moylneux and John Ashton their Heirs and Assigns and to the Only proper use and behoof of them the said John Carroll Robert Moylneux and John Ashton their Heirs and Assigns forever, and for no other Intent or Purpose Whatever, and the said William Deakins Junr and John Threlkeld doth by these Presents Covenant grant and agree to and with the said John Carroll Robert Moylneux and John Ashton their Heirs and Assigns that they the said William Deakins Junr and John Threlkeld shall and will warrant and forever defend the aforesaid Lott of Ground and Premises unto them the said John Carroll Robert Moylneux and John Ashton their Heirs and Assigns forever against all Manner of Person or Persons claiming any Right Title they to by from or under them the said William Deakins Junr and John Threlkeld In Witness whereof the said William Deakins Junr and John Threlkeld hath hereunto set their hands and Seals the day and Year first above Written.

Sign'd Sealed & Delivered
In the Presence of
The Words, one half Degree & the Word, here being first Enterlined

Richard Thompson

Bernard O Neill

Will Deakins Junr (Seal)

John Threlkeld (Seal)

Since the mid-1800s, Georgetown's founding has been tied to the date of this deed, January 23, 1789, when Georgetown's founder, John Carroll, S.J., purchased a one-acre plot of land for the campus. Carroll's selection of this site was influenced by many factors, including the establishment of Holy Trinity Church nearby and aesthetic features like "salubrity of air" and "cheapness of living," mentioned in his *Proposals for Establishing an Academy*. But the location was significant also because, unbeknownst to Carroll, the Federal District of Columbia soon would be located nearby and forever tie Georgetown's history with the history of the nation's capital. (GU Archives.)

The College History Series

GEORGETOWN UNIVERSITY

PAUL R. O'NEILL AND PAUL K. WILLIAMS

ARCADIA

First published 2003
Reprinted 2003

Published by Arcadia Publishing
Charleston SC, Chicago IL, Portsmouth NH, San Francisco CA

Printed in the United States of America

Library of Congress Catalog Card Number: 2002117621

For all general information contact Arcadia Publishing at:
Telephone 843-853-2070
Fax 843-853-0044
E-mail sales@arcadiapublishing.com
For customer service and orders:
Toll-Free 1-888-313-2665

Visit us on the Internet at www.arcadiapublishing.com

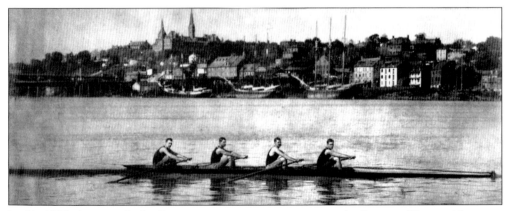

In this 1886 photograph, the Georgetown crew team appears on the Potomac River amidst cargo schooners that once carried coal to Boston and returned to Georgetown carrying ice—the only form of refrigeration then available. (GU Archives.)

CONTENTS

ACKNOWLEDGMENTS

The authors could not have compiled this book without the expertise and guidance of University archivist Lynn Conway, assistant archivist Heather C. Bourk, and Arcadia Publishing editor Laura New. Those who have studied the history of Georgetown University know the indispensable resource provided by Dr. Emmett Curran's book, *The Bicentennial History of Georgetown University, Volume I.* Editing and fact-checking were generously conducted by Kevin Nalty (COL '91), Scott Minto (SFS '02), Gregory J. Alexander, and Judy Pezza Rasetti. Also, acknowledgement goes to the staff of the Washingtoniana Division of the Martin Luther King Jr. Memorial Library (MLK).

Finally, the authors would like to thank their family and friends, whose love makes life worthwhile.

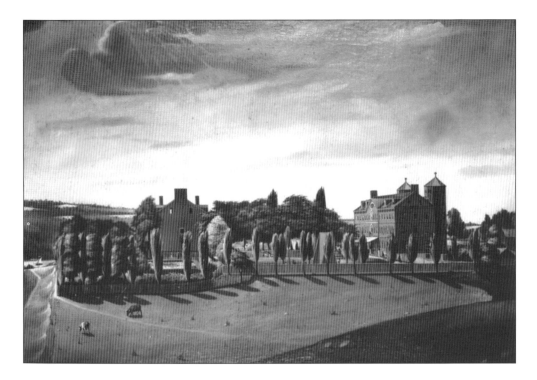

INTRODUCTION

Few people know that a mid-19th century typographical error is central to the history of Georgetown University's founding. Historian Emmett Curran discovered that until the 1840s, Georgetown actually traced its beginning to 1788—the year that construction began on Old South, the first campus building. Somehow (probably by accident), the 1851 college catalogue incorrectly listed 1789 as the year that construction of Old South began. Subsequent catalogues not only repeated the dating error, but eventually equated Georgetown's founding with this date as well.

Whatever the cause of these errors, their consequences were lasting. Centennial planners— not aware of the mistake—did not question 1889 as the year of the school's 100th anniversary. Why not 1788, the year originally cited and the year the first building was started? How about 1791, the year the first student arrived, or 1792, the year classes finally began? When the error became apparent in the early 1880s, university leaders—no doubt reluctant to compromise the romantic association with 1789 and its significance to our nation—stuck with 1789 as the founding date of Georgetown. After all, they reasoned, 1789 was the year that John Carroll took deed for the first parcel of campus land.

This pictorial history of Georgetown University adds a little more to this detail of Georgetown's founding, but readers will find a host of other facts and anecdotes that, together with images from Georgetown's first 200 years, tell the history of America's oldest Catholic university from its founding to its bicentennial. The selection of portraits, documents, and photographs gives hint to the authors' interest in the school's architecture—that is, "history as bricks-and-mortar." Indeed, many of the images housed in the university archives, District of Columbia libraries, and the Library of Congress focus on the physical development of the campus. But also included are pictures and stories of Georgetown's leaders, students, alumni, and benefactors. Overall, the authors hope the book provides a varied review of Georgetown's past.

Georgetown University is not a comprehensive history, as space limitations dictated how broadly—or narrowly—the authors were able to address many topics. But readers attentive to the details of the centuries-old papers and stereographs will develop a sense of Georgetown that words can only partially convey, and the authors hope that their selections will help bring Georgetown's rich history to life in a unique way.

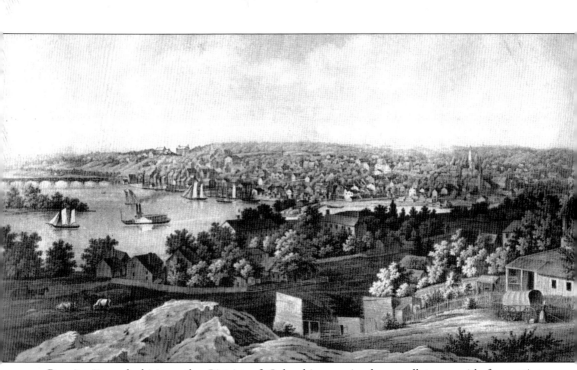

Despite its early history, the District of Columbia remained a small town with few major improvements and buildings until after the Civil War, when thousands of displaced Southerners and freed slaves relocated here in search of work during Reconstruction. Farms and open land are seen here within the city boundaries. Georgetown's campus is depicted as it appeared *c.* 1831, soon after the building campaign of Pres. Thomas Mulledy, S.J., commenced. (GU Art Collection.)

One

FOUNDING AND
THE EARLY YEARS

"We shall begin the building of our Academy this summer," wrote Georgetown University founder John Carroll in March 1788 to his friend and longtime correspondent Charles Plowden of England. Four years later, in 1792, without an endowment—indeed, without any substantial means of financial support at all—the "Academy at George Town, Potowmack River, Maryland" began classes on a small parcel of land on a hilltop overlooking a busy tobacco port.

This chapter guides readers from the founding of the university—illustrated with important and early documents—to the emerging built environment of the early-19th century campus. Less then a decade after John Carroll's founding, the students and faculty of Georgetown gathered to witness an address by President George Washington from the porch of Old North in 1797, when the capital city itself was still in its infancy and lacked any permanent government buildings, monuments, or adequate housing. For much of its early history, the college was focused on construction. Its first student, William Gaston, later petitioned his fellow Congressional members to allow Georgetown College the authority to grant academic degrees, which began in 1815. Students formed the Sodality in 1810, and shortly thereafter a dramatic society called Mask and Bauble. However, the founding fathers spent much of their time during the institution's infancy raising funds and planning for future growth; subsequently, the focus of campus activities remained in just two buildings, Old North and Old South, until the 1830s. As the campus slowly grew in physical size in the early 19th century, several amenities were constructed to correspond to the expanding role of the Jesuit-run facility, including an infirmary, observatory, and store, as well as the expansion of scholastic offerings, including the establishment of a medical school in 1850.

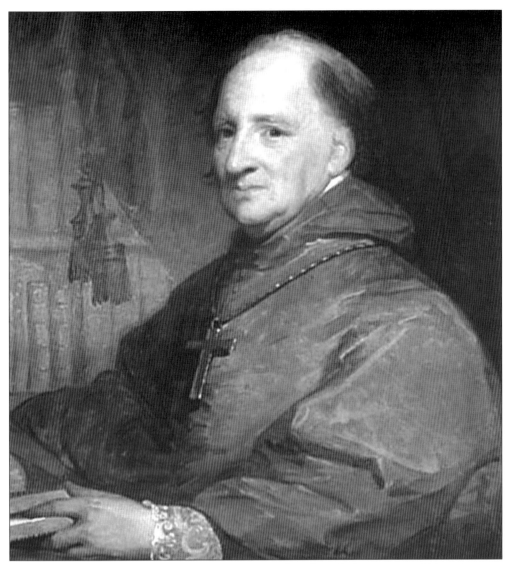

This portrait of John Carroll, S.J., (1735–1815), founder of Georgetown University, was completed by Gilbert Stuart *c.* 1804. Carroll, the son of an Irish immigrant, was born in 1735 in Maryland and educated in Europe. In 1753, Carroll entered the Society of Jesus in the Netherlands and was ordained in 1761. The suppression of the Jesuit order prompted Carroll to return to America in 1774, where he undertook missionary work along the shores of the Potomac River and Rock Creek. Although not substantially involved in the American Revolution (his cousin Charles Carroll was a signer of the Declaration of Independence), Carroll's appointment in 1789 as the first Catholic bishop in America came in response to the new nation's guarantee of religious freedom and the need for a spiritual authority in the former colonies. As Bishop of Baltimore, Carroll assumed the burden of providing clergy for the American church, and his desire to found a school stemmed from his belief that the future of the Catholic Church in America (and probably his success as bishop) depended on the education of Catholic men to serve as clergy. After years of consideration and several failed starts, Carroll purchased a small parcel of land on a hilltop overlooking a busy tobacco port and founded the "Academy at George Town, Potowmack River, Maryland." (GU Art Collection.)

PROPOSALS

FOR ESTABLISHING AN

ACADEMY,

AT GEORGE-TOWN, PATOWMACK-RIVER, MARYLAND.

THE Object of the proposed Institution is, to unite the Means of communicating Science with an effectual Provision for guarding and improving the Morals of YOUTH. With this View, the SEMINARY will be superintended by those, who, having had Experience in similar Institutions, know that an undivided Attention may be given to the Cultivation of Virtue, and literary Improvement; and that a System of Discipline may be introduced and preserved, incompatible with Indolence and Inattention in the Professor, or with incorrigible Habits of Immorality in the Student.

The Benefit of this Establishment should be as general as the Attainment of its Object is desirable. It will, therefore, receive Pupils as soon as they have learned the first Elements of Letters, and will conduct them, through the several Branches of classical Learning, to that Stage of Education, from which they may proceed, with Advantage, to the Study of the higher Sciences, in the University of this, or those of the neighbouring States. Thus it will be calculated for every Class of Citizens—as READING, WRITING, ARITHMETIC, the easier Branches of the MATHEMATICS, and the GRAMMAR of our NATIVE TONGUE will be attended to, no less than the LEARNED LANGUAGES.

Agreeably to the liberal Principle of our Constitution, the SEMINARY will be open to Students of EVERY RELIGIOUS PROFESSION.——They, who in this Respect differ from the SUPERINTENDENTS of the ACADEMY, will be at Liberty to frequent the Places of Worship and Instruction appointed by their Parents; but, with Respect to their moral Conduct, all must be subject to general and uniform Discipline.

In the Choice of Situation, Salubrity of Air, Convenience of Communication, and Cheapness of living, have been principally consulted; and GEORGE-TOWN offers these united Advantages.

The Price of Tuition will be moderate; in the Course of a few Years, it will be reduced still lower, if the System, formed for this SEMINARY, be effectually carried into Execution.

Such a Plan of Education solicits, and, it is not Presumption to add, deserves public Encouragement.

The following Gentlemen, and others, that may be appointed hereafter, will receive Subscriptions, and inform the Subscribers, to whom, and in what Proportion Payments are to be made :—In Maryland—The Hon CHARLES CARROLL, CARROLLTON, HENRY ROZER, NOTLEY YOUNG, ROBERT DARNALL, GEORGE DIGGES, EDMUND PLOWDEN, Esqrs, Mr. JOSEPH MILLARD, Capt. JOHN LANCASTER, Mr. BAKER BROOKE, CHANDLER BRENT, Esq; Mr. BERNARD O'NEILL and Mr. MARSHAM WARING, Merchants, JOHN DARNALL, and IGNATIUS WHEELER, Esqrs, on the Western-Shore; and on the Eastern, Rev. Mr. JOSEPH MOSLEY, JOHN BLAKE, FRANCIS HALL, CHARLES BLAKE, WILLIAM MATTHEWS, and JOHN TUITTE, Esqrs.—In Pennsylvania—GEORGE MEAD and THOMAS FITZSIMMONS, Esqrs, Mr. JOSEPH CAUFFMAN, Mr. MARK WILCOX, and Mr. THOMAS LILLY.—In Virginia—Col. FITZGERALD, and GEORGE BRENT, Esq;—and at New-York, Dominic LYNCH, Esquire.

SUBSCRIPTIONS will also be received, and every necessary Information given by the following Gentlemen, Directors of the Undertaking :—The Rev. Messrs JOHN CARROLL, JAMES PELLENTZ, ROBERT MOLYNEUX, JOHN ASHTON, and LEONARD NEALE.

Proposals for Establishing an Academy at George-Town, Potowmack-River, Maryland, dated November 1786, is the earliest printed document relating to Georgetown's founding. *Proposals* describes Carroll's plan to establish a school open to "Students of Every Religious Profession" and "every Class of Citizens." Tightly tied with the academy's academic mission were strict provisions for "guarding and improving the morals of youth" as well as the "cultivation of virtue." Although the word "Catholic" does not appear anywhere in the document, printed copies of *Proposals* were broadly distributed among Catholic elites in America and abroad, individuals whom Carroll hoped would fund his new venture. (GU Archives.)

To all liberally inclined to promote the Education of YOUTH.

BE it known by thefe prefents, that I, the underwritten, have ~~appointed~~ *humbly requested* Edw.? Weld Esq.r & Lady to receive any generous donations for the purpofes fet forth in a certain printed paper, entitled,

Propofals for eftablifhing an Academy, at George-Town, Patowmack-River, Maryland;

for which *they* will give receipts to the benefactors, and remit the monies received by *them* to me the aforefaid underwritten, one of the directors of this undertaking.

Confcious alfo of the merited confidence placed in the aforefaid *Edward Weld Esq.r & Lady*

I moreover ~~authorize~~ *desire* *them* to appoint any other perfon or perfons to execute the fame liberal office, as *they are humbly requested* ~~is authorized by me to execute.~~

~~Given at~~ *Maryland,* this 30.th day of *March* 17 87.

Signed and fealed

J. Carroll

Carroll's letter authorizing fund-raising for his proposed school was dated March 1787 and sent to prospective donors along with his *Proposals for Establishing an Academy*. Throughout its history, Georgetown has struggled mightily to secure funds sufficient for its operation and growth. The founding years were particularly challenging. Without the benefit of state sponsorship or private endowment, Carroll relied on modest revenues from Jesuit-owned lands and periodic (though small) bequests from individuals. Indeed, void of Carroll's dogged determination, it is unlikely that Georgetown would have survived much beyond its first decade. (GU Archives.)

Shown here is the campus as it likely appeared in 1792, when Georgetown held its first classes in Old South. Construction for Georgetown's first building began in April 1788. The small Colonial-style structure included 10 or 11 rooms and was positioned with a north-to-south orientation facing the Potomac River, a pattern followed by campus buildings for almost 100 years until Healy Hall was erected to face eastward toward the city. Old South was demolished in 1904 and replaced by Ryan Hall. (GU Art Collection.)

This portrait shows Rev. Robert Plunkett, the first president of Georgetown (1791–1793). Recruiting someone to serve as president proved an onerous task for John Carroll, and many of his preferred candidates declined his entreaties. Plunkett took the job but served for only 18 months. At the time, Georgetown comprised three divisions— elementary, preparatory, and college. The elementary division was open to "any literate eight-year-old of respectable behavior." (GU Art Collection.)

Misbehaving students in the early years were sometimes sent to a room atop one of Old North's octagonal towers where, as *Scribner's Monthly* reported, an "air of pensive solace" could be found for the student "prisoners" to consider the error of their ways. Sympathizers of the penitents were known to hoist food up to them secretly, even at the risk of themselves being "imprisoned." (Authors' Collection.)

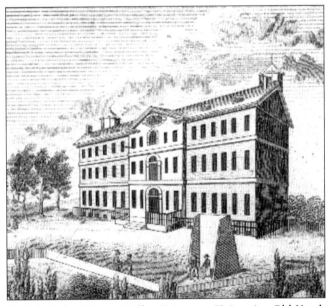

Modeled after Nassau Hall at Princeton University, Old North (the oldest surviving building on campus) was started in 1794 after John Carroll purchased two acres of farmland to enlarge the campus. By Georgetown standards then, Old North was massive—measuring almost three times longer than Old South—and it clearly reflected Carroll's lofty ambitions for the school. (GU Art Collection.)

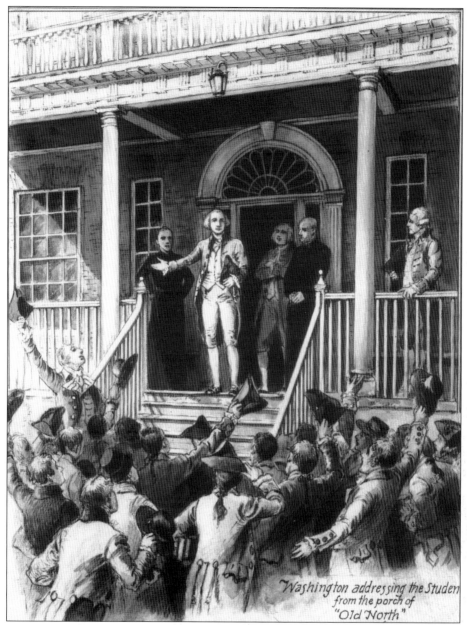

Washington addressing the Students from the porch of "Old North"

In August 1797, George Washington visited the campus and addressed students from the porch of Old North. The college diary recalls Washington's arrival alone on horseback to visit the campus where his grandnephews, Bushrod and Augustine, were students during his presidency. This artist's rendition of the event is undated, but an anomaly in the drawing dates its creation at the end of the 19th century. The number of steps leading from the porch of Old North to the students gathered below reflects the scene only as it would have appeared after 1892, when the Quadrangle in front of Old North was lowered to accommodate the construction of Dahlgren Chapel. Although there is no doubt that Washington addressed students from the porch of Old North, the level of the Quadrangle in 1796 was much higher, and the students would have stood almost at eye-level with Washington. (GU Archives.)

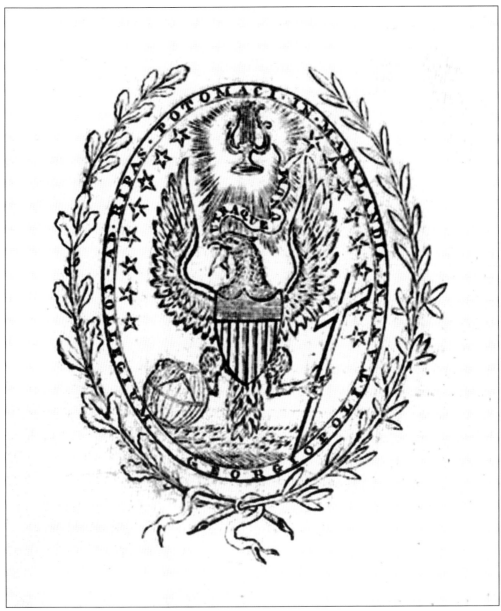

The original Georgetown University seal was financed by a gift in 1798 from Justine Douat, a nurse who cared for students on campus. The 16 stars that surround the eagle in the center date the seal at sometime between 1796 (when Tennessee was admitted to the Union) and 1802 (when Ohio, the 17th state, was admitted). The Latin inscription surrounding the seal is *Collegium Georgiopolitanum Ad Ripas Potomaci in Marylandia*, indicating Georgetown's original location on the Potomac River in Maryland (boundaries for the District of Columbia were not set until 1792). The use of this seal was discontinued in 1844 when the university was incorporated. It was not until 1977 that this original design was reinstated as the university's official seal. (GU Archives.)

THIRTEENTH CONGRESS OF THE UNITED STATES;

AT THE THIRD SESSION,

Begun and held in the city of Washington, in the Territory of Columbia, on Monday the nineteenth day of September, one thousand eight hundred and fourteen.

AN ACT *Concerning the College of George Town in the District of Columbia.*

Be it enacted by the Senate and House of Representatives of the United States of America in Congress assembled, That it shall and may be lawful for such persons, as now are, or from time to time may be, the President and Directors of the College of George Town, within the District of Columbia, to admit any of the students belonging to said college or other persons meriting academical honors, to any degree in the faculties, arts, sciences, and liberal professions, to which persons are usually admitted in other colleges or universities of the United States; and to issue in an appropriate form, the diplomas or certificates, which may be requisite to testify the admission to such degrees.

March 1, 1815
Approved
James Madison

Langdon Cheves. Speaker of the House of Representatives.

John Gaillard, President of the Senate pro tempore.

I certify that this act originated in the House of Representatives

John Carroll's fear of meddling with public authority kept him from seeking a public charter for Georgetown when it was founded. Due to its location in the Federal District, the "College of George Town in the District of Columbia" received a federal rather than a state charter to grant academic degrees in 1815. (The United States Military Academy was the only other school to have received such authorization by this time.) (GU Archives.)

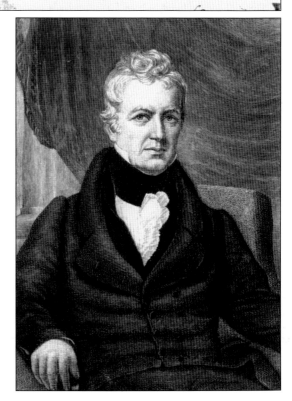

While serving as a United States Congressman, William Gaston presented the "petition of the President and Directors of Georgetown College" for authority to grant academic degrees. Gaston, Georgetown's first student, arrived on campus in late 1791, at the age of 13. He left two years later due to illness and went on to graduate from the College of New Jersey (later Princeton University). Gaston Hall in Healy Hall is named in his honor. (GU Archives.)

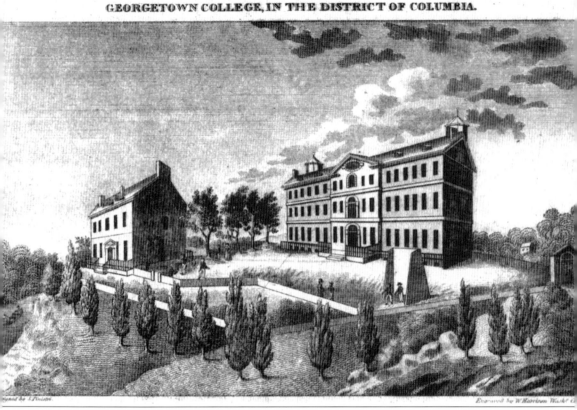

GEORGETOWN COLLEGE, IN THE DISTRICT OF COLUMBIA.

Until the 1830s, Old South (left) and Old North (right) were the only significant buildings at Georgetown, but the campus itself was expanding through the purchase of dozens of acres of farmland adjacent to the original campus. Accounts vary, but Georgetown's campus was probably close to 200 acres before mounting debts required a substantial sale of property north of present-day Reservoir Road in the late 19th century. (GU Art Collection.)

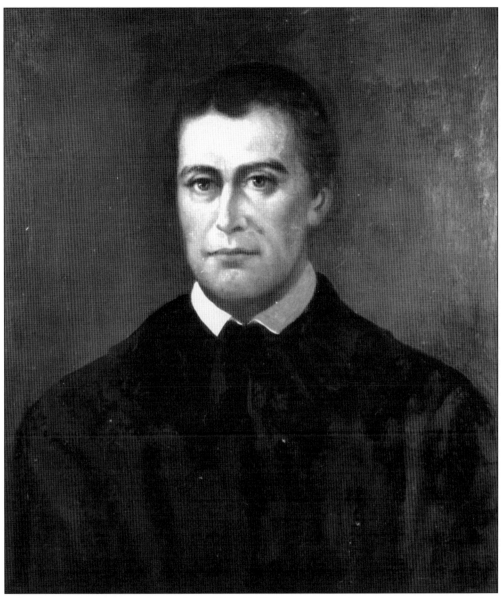

Italian-born John Anthony Grassi, S.J., (1812–1817) became president of Georgetown at a time when the school's financial circumstances and prospects for survival could not have been worse. Desperately short of funds, Georgetown had come into competition with a northern neighbor, the Jesuit-run Literary Institute of New York. With an insufficient number of prospective students to sustain both schools—and considering Georgetown's bleak financial straits—a decision was made to close either the Literary Institute or Georgetown. Advocates of the Literary Institute protested that Washington was a "backwards town with no future, an unsuitable location for a school." New York, on the contrary, "was rapidly becoming the metropolis of the nation." Grassi, however, declared the federal city a future world capital and affirmed that "no city in the nation would be more suitable for the home of a great university." The Literary Institute was closed in April of 1814. (GU Art Collection.)

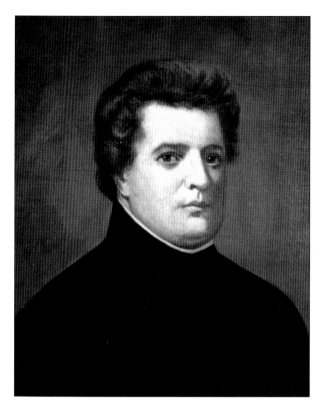

Thomas F. Mulledy, S.J., two-time president of Georgetown (1829–1837, 1845–1848), began his first term in 1829 and undertook a building campaign that substantially transformed the campus. In 1843, Mulledy served as the first president of the College of the Holy Cross in Worcester, Massachusetts. Unable to secure an educational charter from the Massachusetts legislature, Holy Cross conferred degrees under authority of Georgetown University for more than 20 years. (GU Art Collection.)

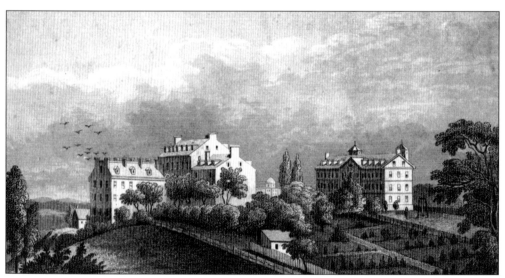

Beginning in 1830, an infirmary (Gervase) and a large academic building (Mulledy) were added to the south side of campus. When these buildings were commandeered in 1862 for use as a Civil War hospital, enterprising Pres. John Early, S.J., (1858–1866, 1870–1873) set about counting the number of wounded soldiers and the square footage of used rooms, documented every damaged good, and presented a bill to the Office of the Quartermaster General, which ultimately went unpaid. (MLK Library.)

The Class of 1873–1874 was photographed near the present site of Healy Hall with the southeast corner of the Old North building visible to the left. In the distance, Visitation Academy can be seen, in addition to the stone wall that runs along 37th Street. (GU Archives.)

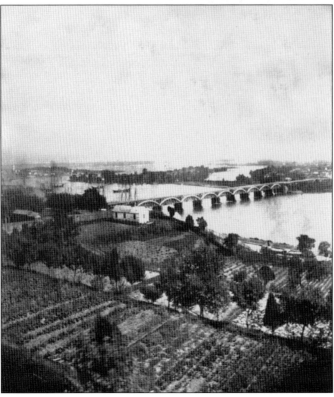

Vegetable gardens and a tool house were all that appeared between the Georgetown campus and the city of Washington in this 1874 photograph. Clearly visible is the Aqueduct Bridge (dismantled when the Key Bridge was built) as well as Anolastan Island (now Theodore Roosevelt Island). Barely visible in the far left background is the unfinished Washington Monument. Construction for that landmark was suspended during the Civil War and was not completed until 1885. (GU Archives.)

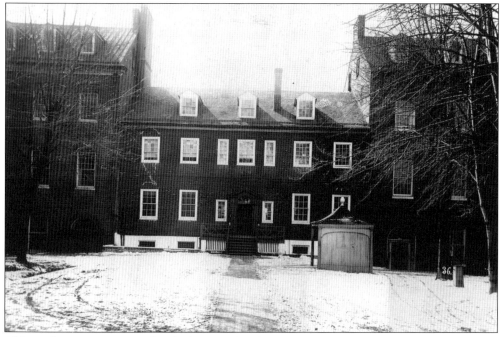

Old South is seen in an undated photograph. The campus pump appears to the right of Old South's main stairs. The Maguire building is shown to the left and the Mulledy building on the right. (GU Archives.)

Rising at 5 a.m., Georgetown students in the early 1800s began their day with "a run to the yard pump for washing and combing." Pictured here in a photograph from 1875, the pump stood in front of Old South and next to a wooded area that later served as the site of Dahlgren Chapel. A commemorative replica of the pump remains on this same spot in today's Quadrangle. (GU Archives.)

This rare 1872 image captures the south side of Old South prior to its demolition in 1904. The statue of St. Joseph, seen at the right, was placed in the garden in 1872, the same year that a smallpox epidemic swept through Washington, D.C. Perhaps miraculously, the campus was not infected by the virus and the statue of St. Joseph was thereafter venerated by students for its role in protecting the school from harm. (GU Archives.)

Another rare photograph from 1872 features the southwest corner of the Gervase student infirmary. The covered porch was known as "Father's recreation porch," beneath which was the tailor shop of Jesuit Brother Bausenwein. (GU Archives.)

DRAMATIC ASSOCIATION
—OF—
GEORGETOWN COLLEGE

TERMINATION OF THE FIRST SESSION

OF THE SCHOLASTIC YEAR, TO BE CELEBRATED BY A

Grand Intellectual and Dramatic

ENTERTAINMENT.

Monday Evening, February 7th, 1853,

Will be performed Sheridan's brilliant Play, in 5 acts of

~ell PIZARRO. ~m

SPANIARDS

Pizarro	Joseph Callanen
Iago	B. J. Semmes
Valverde	J. P Donnelly
Almagro	Peter McGary
Davilla	Joseph H. Blandford
Las Casas	Alex. H. Loughborough
1st Soldier and Sentinel	George Hamilton
2d Soldier	James Dougherty

PERUVIANS

Ataliba	Constant F. Smith
Rolla	Harvey Bawtree
Alonza, (a Spaniard who has joined the Peruvians)	Eugene Longuemare
Orozembo	Jules Choppin
Orano	Wm. H. Gwynn
Old Man	John J. Beall
Boy	James R. Randall
1st Soldier	Theophilus Perret
2d Soldier	Hugh J. Gaston

To conclude with the amusing and popular Farce of

SLASHER & CRASHER.

Benjamin Blowhard	Joseph Callanen
Sampson Slasher	John J. Beall
Christopher Crasher	James P. Donnelly
Lieutenant Brown	Harvey Bawtree
Wm. Blowhard	Eugene Longuemare
Master Charles	James R. Randall
John	George Hamilton

This flyer announced the 1853 production of *Pizzaro* by the Dramatic Association of Georgetown College, then in its first season. Later called the Mask and Bauble Dramatic Society, it is the oldest running college theater company in the nation. (GU Archives.)

24

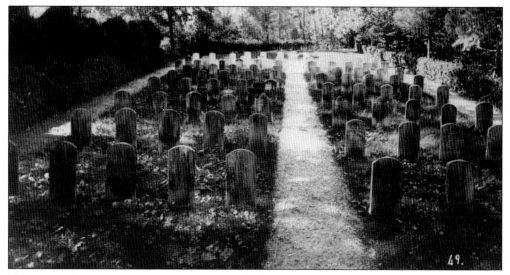

The Jesuit Cemetery on campus was originally located southeast of the Quadrangle but was moved in 1854 to its present site next to Harbin Hall to accommodate the construction of the Maguire building. The cemetery's first burial was in 1808 and many headstones are marked to indicate the decedent as Coadjutor (Jesuit brother), Sacerdos (Jesuit priest), or Scholastic. (GU Archives.)

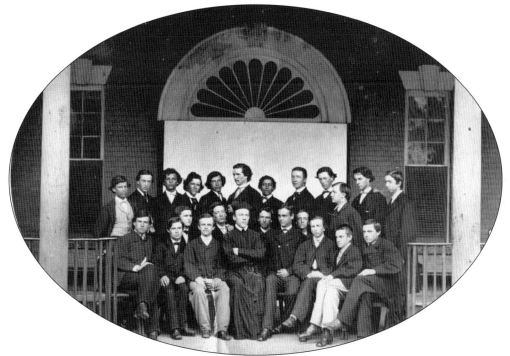

The oldest of Georgetown's student societies, formed in 1810, is the Sodality. Shown here in an 1864 photograph, members of the Sodality intended to "develop the character and spiritual life of the Christian scholar," and were devoted to the Immaculate Conception of the Blessed Virgin Mary. The Sodality of Georgetown is said to have held the first May devotions celebrated in America. (GU Archives.)

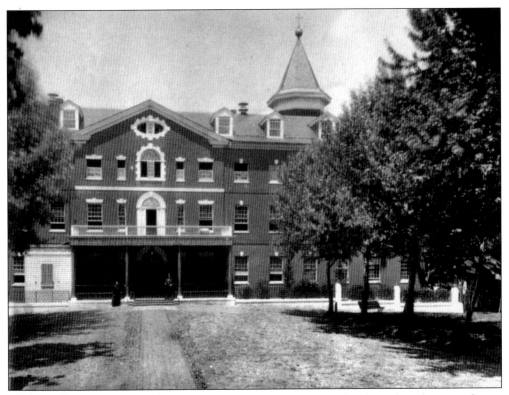

The south facade of Old North is shown in this 1874 photograph, taken from the steps of Old South. Just to the left of the Old North entrance is a small structure, now gone, that served as a porter's lodge, a barber shop, and eventually a lumber room. (GU Archives.)

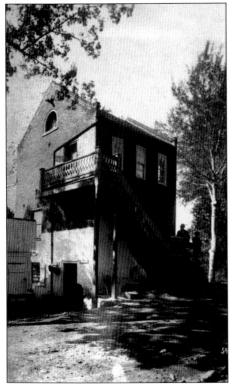

A campus store, bakery, and shoe shop building (pictured here) was erected in 1810 and photographed in 1889. The building, which stood near the site of present-day Village C, was demolished in 1908. (GU Archives.)

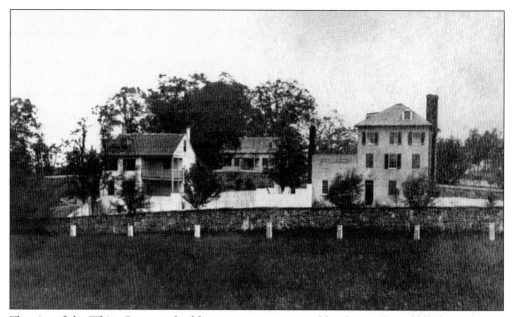

The site of the White-Gravenor building was once occupied by the residence of Susan Decatur and another structure called the Bachelor's House. Bachelor's House was named as such because it served as a residence for secular teachers in the 1860s. In the foreground of the photograph is part of today's Copley Lawn that was once the school's ball field and track. (GU Archives.)

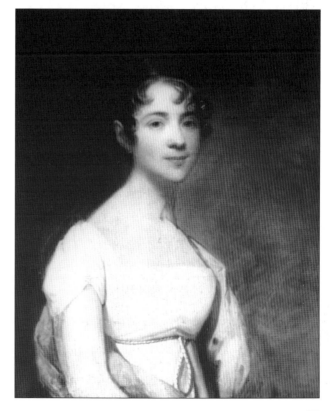

In 1834, Susan Decatur, one of Georgetown's first benefactors, made a gift of $7,000 (money that her husband, Adm. Stephen Decatur, received from the Tripolitan War) under the condition that she receive an annuity of $630 per year. However, Mrs. Decatur lived until 1860—so long that the annuities paid to her far exceeded her original gift. (Mr. and Mrs. William Machold/GU Archives.)

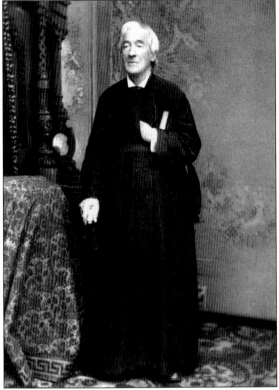

James Curley, S.J., founded the Georgetown observatory after securing funds for the project in 1841. The observatory—one of the first in the United States—was of Curley's own design and was located at the far western edge of the campus. Curley, pictured here in a photograph dated 1886, taught natural philosophy (now called physics), botany, chemistry, and astronomy at Georgetown for 50 years. (GU Archives.)

This print appeared in the Washington, Goggin & Combs' "Catalogue of Officers and Students of Georgetown College for Year 1852–3." The "Astronomical Observatory," completed in 1844, was used in 1846 to determine the latitude and longitude of Washington, D.C., and was the first such calculation for the nation's capital. The observatory was entered into the National Register of Historic Places in 1973. (MLK Library.)

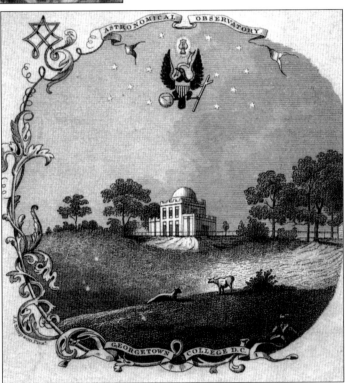

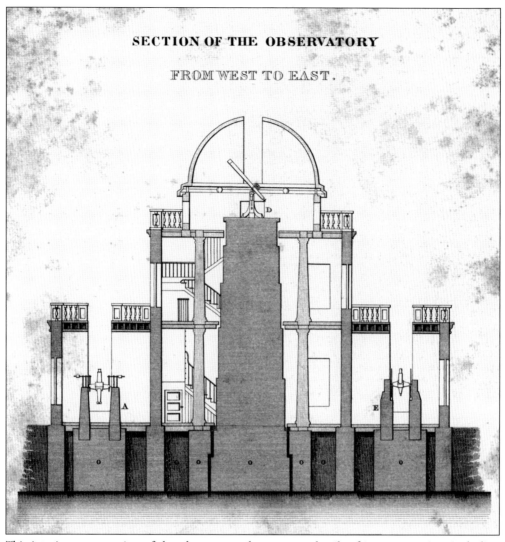

SECTION OF THE OBSERVATORY

FROM WEST TO EAST.

This interior cross-section of the observatory shows many details of its construction, including three-foot-thick foundations and granite piers. The plan also notes the location of the transit instrument, equatorial telescope, and meridian circle—all world-class imports from Europe. Georgetown's astronomy department was itself considered world-class and became the largest such program in the world by 1967. The major was phased out in 1972, however, due to lack of funding and, not incidentally, because of the observatory's proximity to the bright lights of Washington, D.C. (GU Archives.)

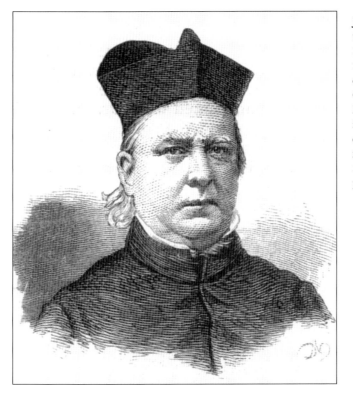

James Ryder, S.J., served two terms as president between 1840 and 1845 and 1848 and 1851. Under Ryder, the college was incorporated by Congress in 1844 and the Medical School was founded in 1850. Ryder also led the construction of a new church for Holy Trinity Parish in 1852, where he served as pastor. (GU Archives.)

Georgetown was incorporated by Congress on June 10, 1844, as "The President and Directors of Georgetown College." Prior to this, the school operated without a corporate charter, as the 1815 Act of Congress simply authorized Georgetown's awarding of academic degrees. This round version of the school seal was created at the time of incorporation and was used until 1977. Although the seal's design closely resembles the 1798 version, it incorporates only 13 stars, perhaps as an attempt to more closely link Georgetown's founding with that of the United States. (GU Archives.)

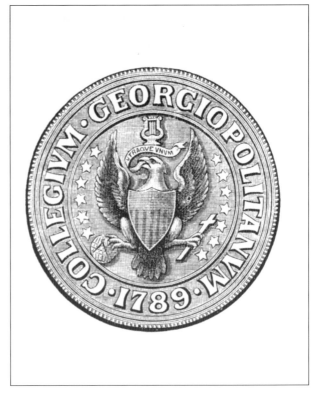

Two

THE CIVIL WAR
AND THE
"SECOND FOUNDING"

The later years of the 19th century marked Georgetown's transition from college to university. Georgetown presidents from early in the century had sown the seeds of this change—by founding two professional schools, introducing a science curriculum, and nurturing graduate programs—but it was the presidency of Patrick F. Healy, S.J., Georgetown's "second founder," that had the most momentous impact on the school.

This chapter illustrates the evolution of Georgetown from college to university and its centennial milestone. From a small cluster of buildings amidst a vast open estate, under the leadership of Patrick Healy in the mid-19th century, the college grounds and infrastructure were vastly expanded and improved. But this was not before plans were put on hold while many of its students trained and participated in the Civil War, which often led to personal conflicts along the serene Walks and heated debates in the classrooms. In the war's later years, the campus itself was forcefully occupied by several infantry companies and utilized for housing, hospitalization, and even surgery for soldiers injured during battle in Maryland and Virginia. In 1870, a law school was formed, and with the inauguration of Pres. Patrick Healy in 1873, the campus began a rapid and impressive expansion with notable buildings such as Healy Hall, completed in 1877. Vast interior rooms and the Riggs Library took years to complete after an exhausting fund-raising campaign. A variety of sporting activities were established among the students beginning in the 1880s and 1890s, who eagerly posed for group photographs.

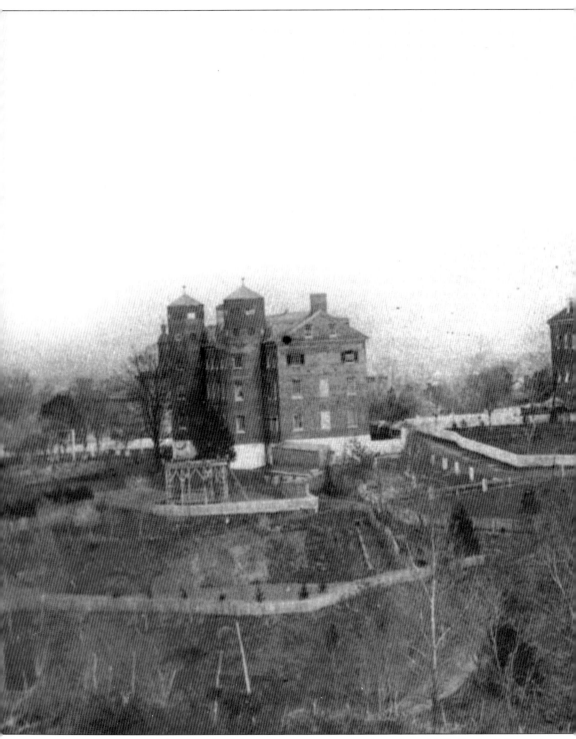

This earliest-known photograph of the Georgetown campus dates from 1865. To the left stands Old North (1795). To the right are Maguire (1855), Old South (1791), Mulledy (1833), and the Gervase Infirmary (1830). Apart from the small cluster of buildings, the plantation-like campus

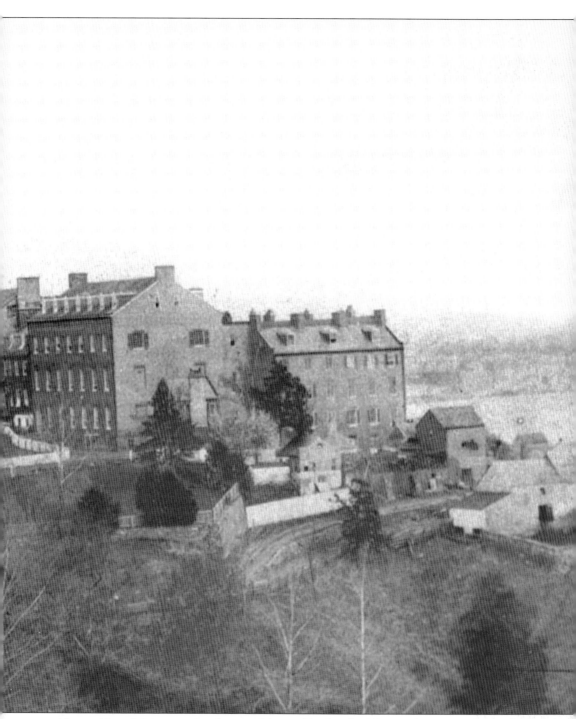

provides no hint of the expansive changes that would take place during the tenure of Patrick F. Healy, S.J., 10 years later. (GUA.)

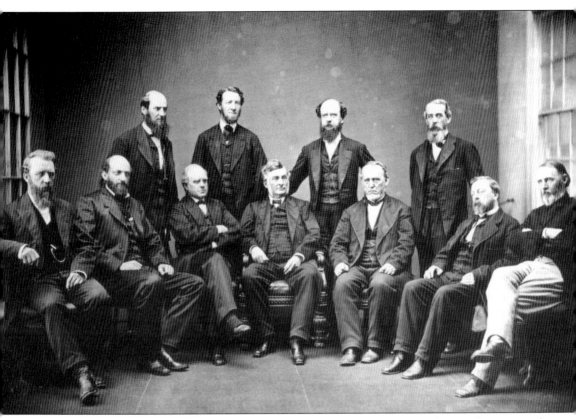

This photograph of the Georgetown College Medical School faculty was taken in the spring of 1868. Georgetown's Medical School was founded in 1850. Candidates for medical degrees at Georgetown were required to be of "good moral character" and "not under twenty-one years of age." They were also required to study medicine for three or more years and to have attended at least one course of both practical anatomy and clinical instruction. Warwick Evans, the first graduate of the Medical School, stands in the back row to the far right. (GUA.)

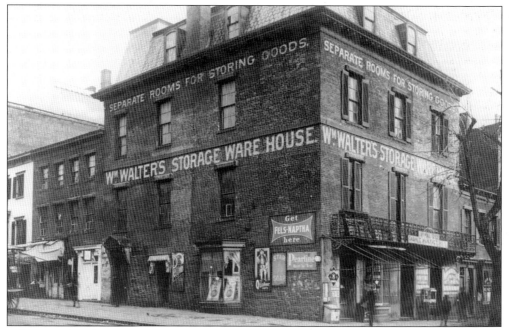

The undersigned are about to establish a Medical College in the D. of Columbia, and respectfully ask, that, the right to confer the degree of M.D. granted to you by your charter, may be extended to them, they desire it to be understood as their object to constitute the Medical Department of George Town College, claiming the usual privilege of nominating the Professors of their Department

(Signed) N. Young, M.D.
F. Howard, M.D.
C. H. Lieberman, M.D.
Johnson Eliot, M.D.

Four local doctors submitted this petition to Georgetown Pres. James Ryder, S.J., in fall of 1849 to establish what would be the first medical school under Catholic auspices in the United States. The physicians were frustrated by exclusionary practices of the Medical Department of Columbian College (now The George Washington University), which controlled the city's lone hospital. (GU Archives.)

A few months after acquiring this warehouse at the corner of 12th and F Streets in 1849, the Medical School acquired an adjacent lot to build a three-story building. By the time its first classes were offered two years later, the facility had grown to include an anatomical laboratory, a dispensary, two lecture rooms, and a six-bed infirmary. (GU Archives.)

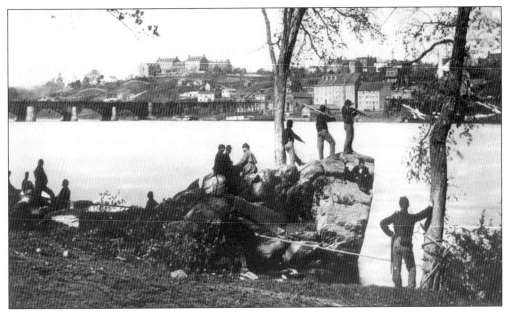

Civil War soldiers are pictured here across the Potomac River from Georgetown *c.* 1865. More than 1,000 Georgetown alumni served in the Civil War—925 with the South and 216 with the North. By the end, 106 Georgetown men died. Although Georgetown's fortunes had brightened considerably in the years leading up to 1861, it was "nearly ruined" by the Civil War. (Library of Congress.)

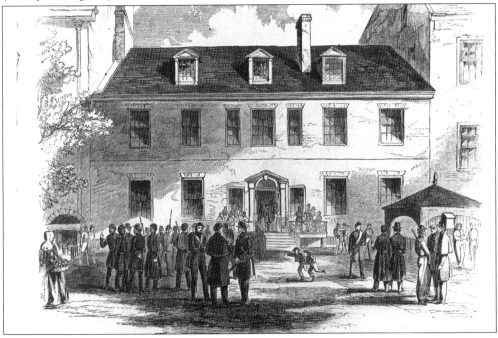

Artist Frank Leslie sketched this image of the campus being used as federal barracks for several regiments of the Union Army during the Civil War. President Lincoln visited campus in May of 1861 to review the 1,400 troops who made the Maguire, Old South, and Mulledy buildings their temporary quarters. (MLK Library.)

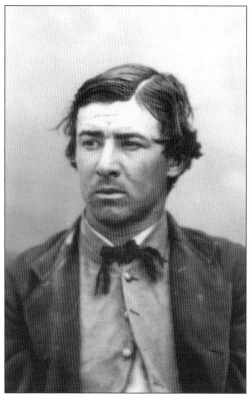

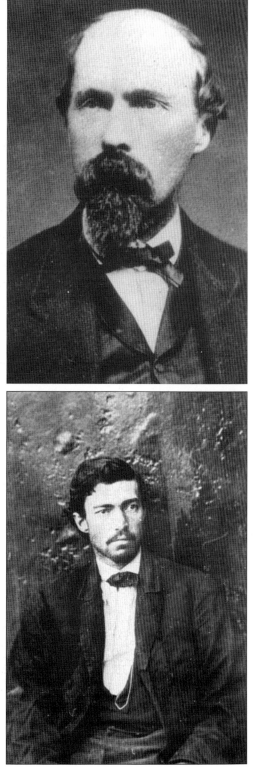

Three of the six individuals convicted of involvement in the 1865 conspiracy to assassinate Abraham Lincoln were Georgetown alumni. Pictured at top left is David E. Herold, who attended Georgetown from 1855 to 1858. Known as "the craftiest of Booth's accomplices," Herold guided John Wilkes Booth after the assassination to the home of Dr. Samuel Mudd (also a Georgetown alumnus, top right) to have Booth's broken ankle set. Samuel Arnold (bottom image), who attended Georgetown in the mid-1840s, was implicated in a separate plot to kidnap Lincoln. Mudd and Arnold were both sentenced to life imprisonment. Herold, on the other hand, was hanged upon conviction. Medical School founder Charles Lieberman (not pictured) treated the dying president after the shooting. (GU Archives.)

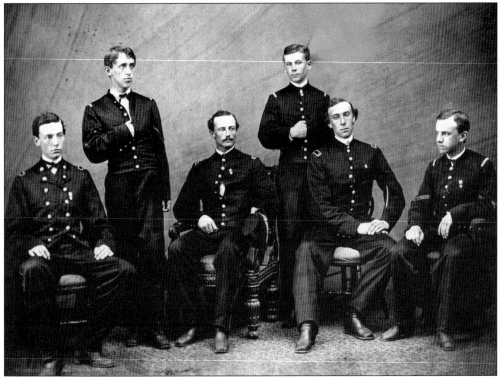

These Georgetown military cadets were photographed on campus in 1869. Georgetown was subjected to myriad Civil War occupations, and a student diary describes the era of "regimental drills all day long . . . Reveille and taps instead of the chapel bells regulate our life," but "beyond a general soiling of the establishment, they [the soldiers] minded their own business, did their own cooking and behaved very well." (GU Archives.)

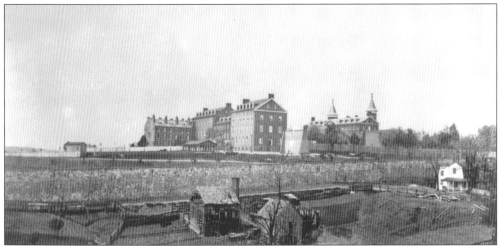

This rare photograph provides a detailed look at the campus as seen from the east in 1867. Readers will recognize the large stone wall bordering what is today 37th Street. One year before the photograph was taken, large conical tops were added to the twin turrets of Old North (right), perhaps to provide a visual balance with the large buildings that had sprung up on the south side of the Quadrangle. (GU Archives.)

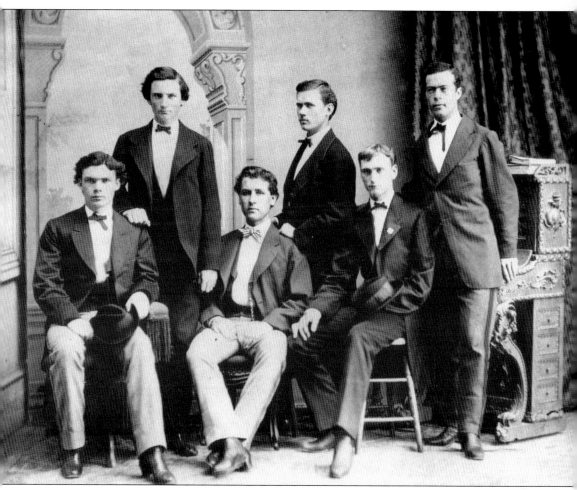

Georgetown conferred only seven Baccalaureate degrees in 1869, and this still portrait of six of the graduates was commissioned for the occasion. Enrollment following the Civil War increased somewhat, but it would be years before Georgetown returned to its pre-war levels of 300-plus students. Nonetheless, Georgetown was making important strides in its late-century quest to become a university, including the founding of a second professional school—the Law School—within the decade. (GU Archives.)

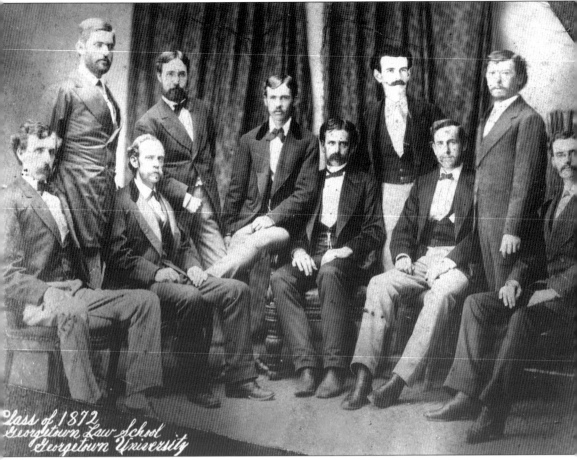

Class of 1872
Georgetown Law School
Georgetown University

The first graduating class of the Law School is pictured here on June 27, 1872. Creation of the Law School was approved in March 1870 in concert with a post–Civil War movement to formalize the study of law in America, but the new professional school also furthered Georgetown's interest in becoming a university. In fact, the Law School's founding is traced in part to the work of Joseph M. Toner, a part-time member of the Medical School faculty. It was Toner who recruited three local lawyers to form the first Law School faculty. (GU Archives.)

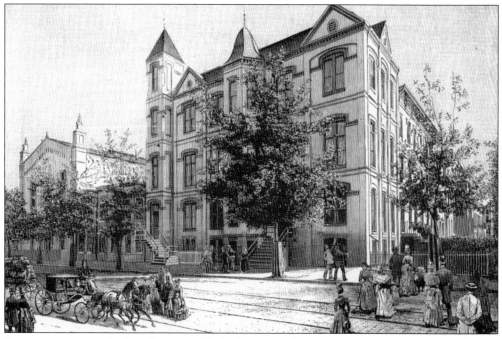

Fourteen years after its founding in 1870, the Law School occupied an entire building for the first time at a former residence at 6th and F Streets, N.W. The school would be housed here from 1884 until 1891. The school's classes for the first two years of its existence were held in a building that was located on the present site of the east wing of the National Gallery of Art. (MLK Library.)

UNIVERSITY OF GEORGETOWN
Law Department,
FIRST
Annual Commencement,
CLASS '72
LINCOLN HALL, WASHINGTON.
Tuesday, June 4th at 8 o'clock, P.M.

The Law School held its first annual Commencement on June 4, 1872 to confer the degree of Bachelor of Laws at Lincoln Hall in Washington, D.C. (GU Archives.)

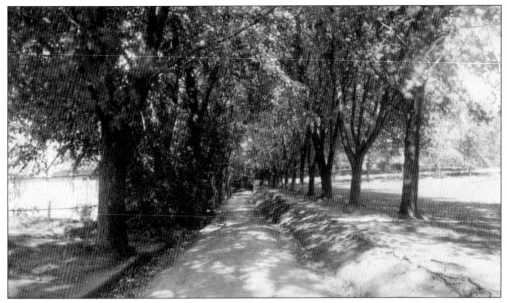

A Maryland farmer named Joseph West became a Jesuit Brother in 1818 and donated funds to purchase a sizable tract of land—much of it virgin forest—to substantially expand Georgetown's campus to the north and west. West himself developed the land, creating a beautiful series of paths, terraces, and trails that became known as the "Walks." The entrance to the Walks, pictured here in 1889, was near the present site of the White-Gravenor building. (GU Archives.)

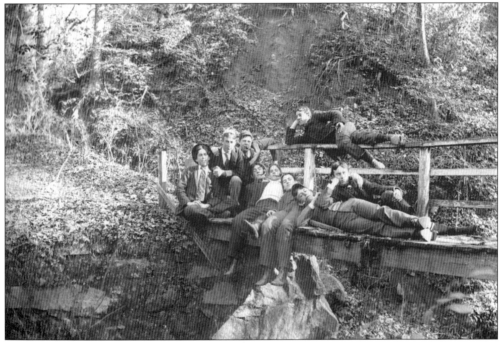

These students were photographed in 1889 lying on one of the many bridges of the Walks. Such casual poses would not have been common a generation before, when the trails were used to stage fistfights to settle "fierce feuds and bitter conflicts" between Northern and Southern students. (GU Archives.)

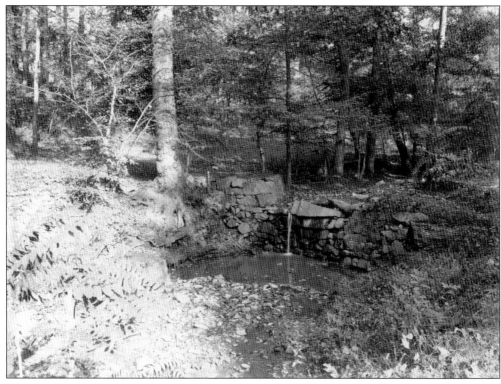

"Niagara Falls," as it was known affectionately by students at the time, was a popular destination along the Walks. (GU Archives.)

Taken in 1874 looking south from the site of today's Reiss Science Building, this photograph captures the heavily wooded, hilly atmosphere of the Walks. Students are seen in the foreground, and barely visible in the distance are the turrets of Old North. (GU Archives.)

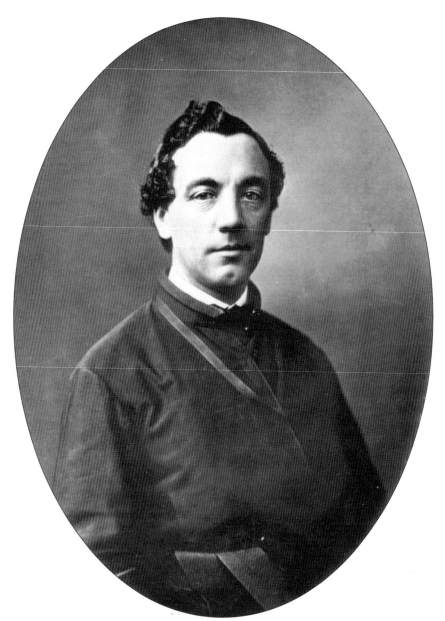

Known as Georgetown's "second founder," Patrick F. Healy, S.J., served as president from 1873 to 1882. Born in 1834, Healy was the son of a white immigrant planter and his black, common-law wife. As such, Healy was born a slave according to 19th-century Georgia law. After being educated in Northern states and Europe, Healy came to Georgetown as a philosophy teacher in 1866. The sudden death of Georgetown president John Early provided the opportunity for Healy to be appointed president. Overcoming skepticism from religious superiors in Rome and a perilous financial position at home, Healy set Georgetown on a developmental course to become a university—linking Georgetown College with the recently established professional schools of medicine and law. Equally important, Healy transformed the physical character of the campus by constructing the massive Romanesque building that bears his name and serves as the visual symbol of the campus today. (GU Archives.)

This rare image is a preliminary study for Healy Hall, submitted in 1876 by the architectural firm of Smithmeyer and Peltz, the same firm that designed the Thomas Jefferson building of the Library of Congress. Although similar in many ways to Healy Hall's final design, this first plan featured a twin spire at the center, and anticipates the demolition of Old North to make room for a wing that would extend westward from the new building's north tower. The cost of executing this more extensive plan most likely eliminated it from final consideration. (Library of Congress.)

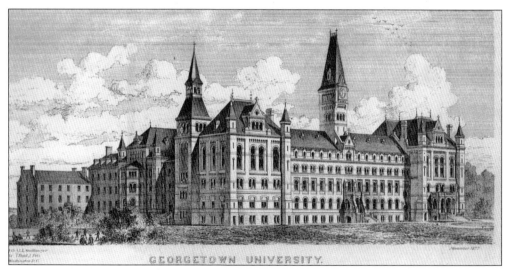

Smithmeyer and Peltz submitted this final design for Healy Hall in 1877. The proposal depicts the ornate Romanesque style that would become the building's signature feature. In place of the twin central spires proposed earlier is a more practical, single tower that would serve as the building's ventilator. Perhaps equal in importance to the building's architecture was its orientation. As historian Emmett Curran notes, positioning Healy Hall to face east toward the city, rather than south toward the river, signaled Georgetown's deliberate shift from a rural to an urban campus. (GU Archives.)

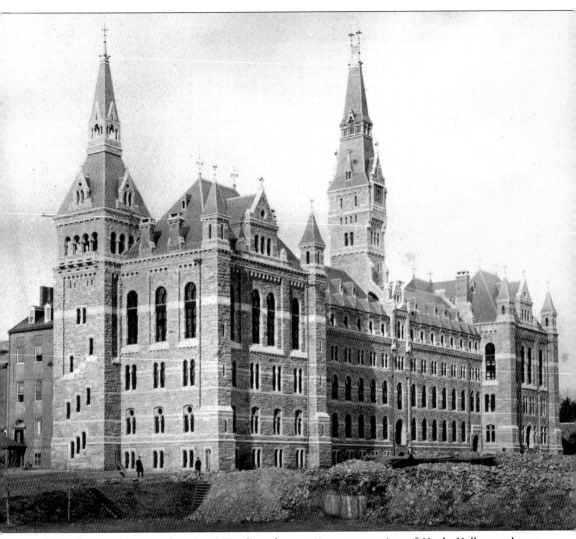

This photograph was taken in 1879 when the exterior construction of Healy Hall was almost complete. The interior of the "New Building" (it was named Healy Hall later against the wishes of Patrick Healy) would remain incomplete for 20 years, and "as late as 1888, the entrance to [Healy] had to be by a set of wooden steps to a temporary door made out of one of the windows near the Old North Building." Indeed, the costs of constructing Healy Hall far exceeded original estimates, and the resulting debt nearly bankrupted the school. However, the landmark structure added 110,000 square feet of instruction and dormitory space—more than all of the buildings then located on campus combined—and visibly symbolized Patrick Healy's aspirations for Georgetown. (GU Archives.)

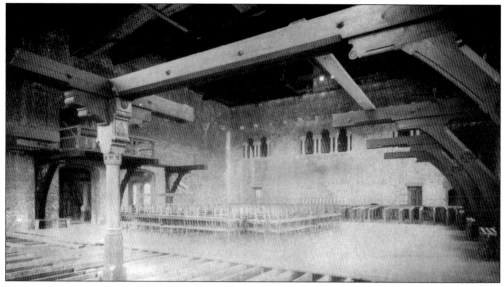

With construction funds exhausted, the auditorium space that would later become Gaston Hall remained unfinished for 20 years. This rare image of the barn-like space was taken between 1896 and 1897, based on dates of interior construction plans. (GU Archives.)

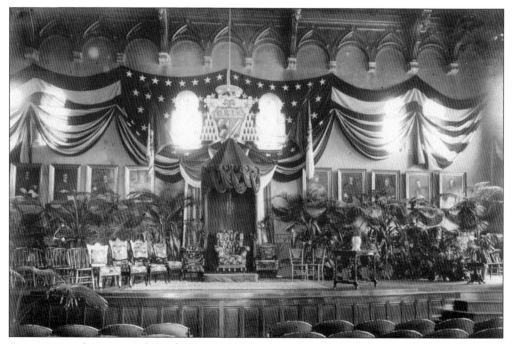

Georgetown alumni raised the funds necessary to finish the interior carpentry of Gaston Hall. The room was "paneled in white Florida pine, with massive polished girders, and an elaborate metal cornice of beautiful design in Gothic arches and brackets finished in bronze." It was not until 1900 that the room was adorned with extensive murals; in the interim, bunting and plants were brought in to decorate the stage. (GU Archives.)

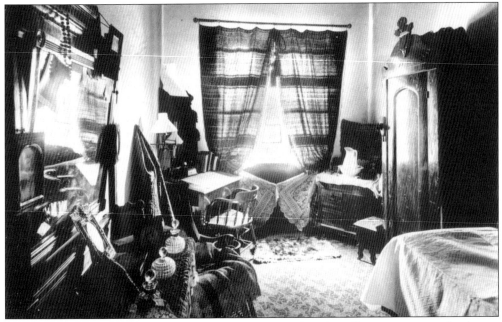

As directed by Patrick Healy, the third and fourth floors of Healy Hall were constructed to house older students in single rooms. This 1901 photograph shows the richly decorated interior of a Healy dormitory room, the plaid curtains somewhat obscuring the familiar curved windows that grace the building's front. (GU Archives.)

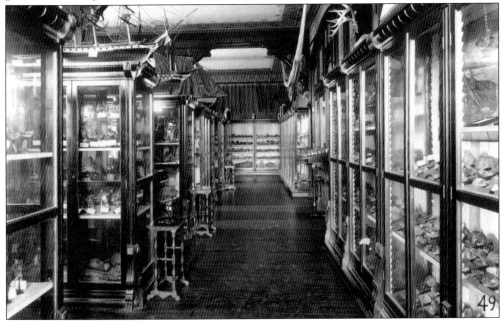

Located within Healy Hall, the Coleman Museum was photographed in 1889. The museum was filled with natural history specimens including a stuffed American eagle, which was moved to the stage in Gaston Hall for commencement and other important proceedings. Later, in 1931, the museum was removed from the second floor of Healy and the space was remodeled into a four-room suite for the President's Office. (GU Archives.)

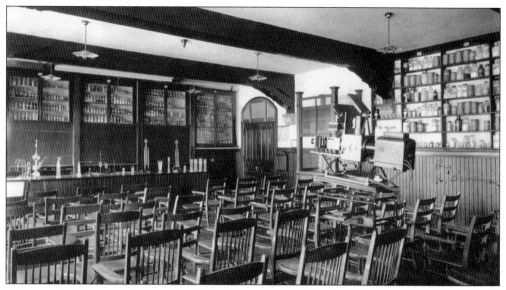

The Chemical Lecture Room in Healy Hall was photographed in 1894. Beginning about 1838, students were taught chemistry and other subjects in "Natural Philosophy" at Georgetown, but the school did not offer a Bachelor of Science degree until 1879. Indeed, Georgetown's curriculum was decidedly "classical." The same set of courses, "united structurally by Latin and Greek," were required of all students, and elective studies as we know them today did not exist. (GU Archives.)

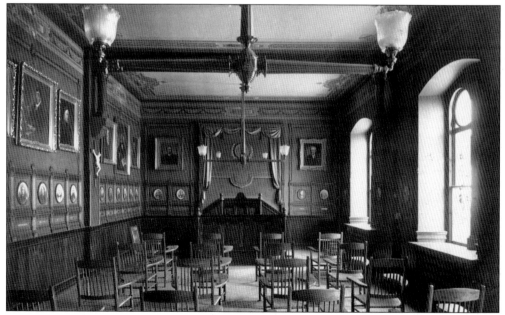

The Philodemic Room in Healy Hall served as home to Georgetown's Philodemic Debating Society, the school's oldest non-religious student group and the only student group granted its own room in the new building. The Philodemic Debating Society was organized in 1830 with the aim of "cultivating eloquence devoted to liberty." The topic for the society's first debate was "Who was the greater man: Napoleon Bonaparte or George Washington?" Washington was declared superior. (GU Archives.)

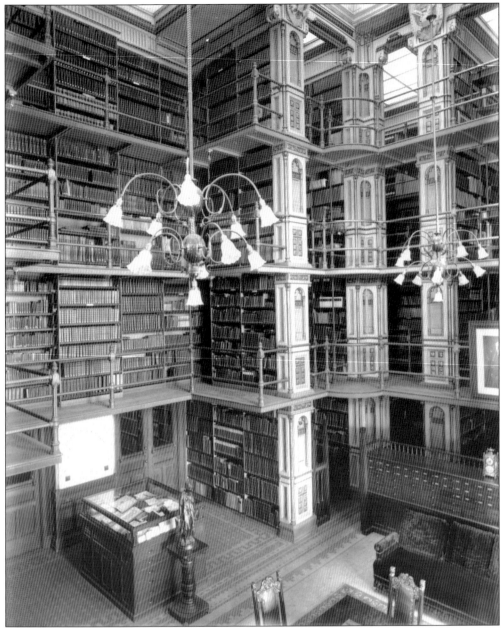

The Riggs Library in Healy Hall was completed in 1889 and funded by a gift made by Francis E. Riggs of Washington, in memory of his father George W. Riggs (founder of Riggs Bank) and his brother Thomas Laurason Riggs (once a student at the school). The Historic American Buildings Survey, housed in the Library of Congress, details the library's rich interior, most especially the four-tier cast-iron book stacks decorated with crosses and decorative squares of Gothic foliage. The ornate space served as Georgetown's main library until Lauinger Library was constructed in 1970. (GU Archives.)

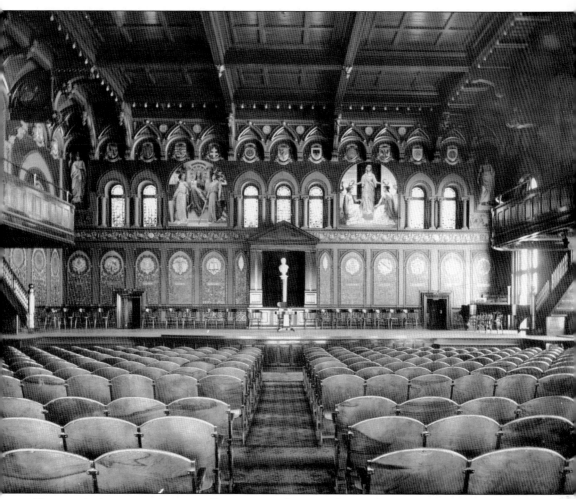

The murals decorating Gaston Hall were created in 1900 by Brother Francis Schroen, S.J., and this photograph was taken shortly thereafter. The large allegorical paintings flanking the arched windows behind the stage are the most prominent in the room. On the left is a depiction of Faith enthroned with Morality and Patriotism at her side. On the right is a painting of Alma Mater giving victory wreaths to Art and Science who sit below her. Other painted features of the room include crests from 60 Catholic colleges and universities throughout the world as well as the names and aphorisms of prominent statesmen and scholars. (GU Archives.)

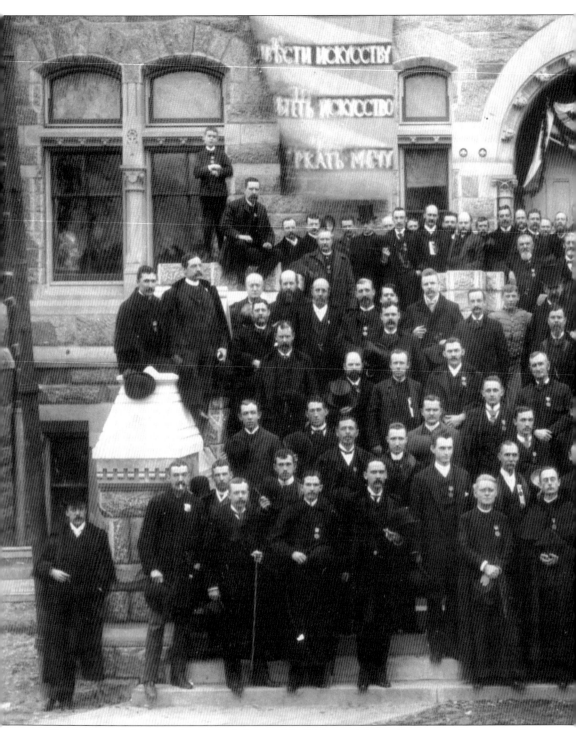

The Society of Alumni gathered on February 21, 1889 to celebrate Georgetown's centennial on the still-unfinished portico of Healy Hall. To the right of the entrance hangs a banner listing "Calverton 1640; Newtown, 1677; Bohemia, 1740; Georgetown, 1789," all names and dates associated with Jesuit schools in early Maryland. To the left hangs a banner with verses of Russian

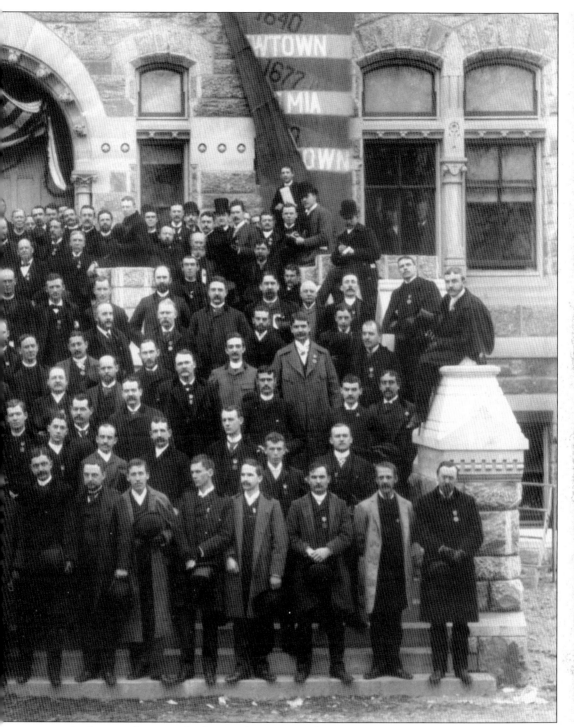

poetry, in honor of Russia's harboring the Society of Jesus during its suppression. The first president of the Society of Alumni was William Corcoran, co-founder of the Corcoran and Riggs banks in Washington, who attended Georgetown in 1813. (GUA.)

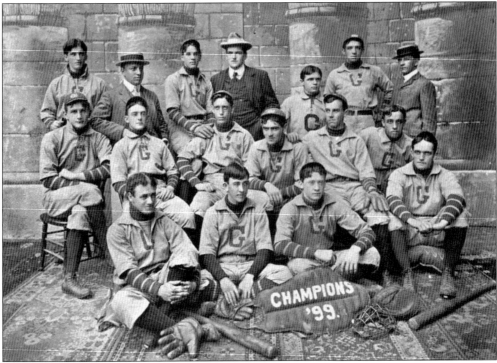

The championship Georgetown baseball team is pictured here in 1899. Georgetown played its first intercollegiate baseball game on May 10, 1870 against Columbian College, when it was located on Meridian Hill in Columbia Heights (today relocated and known as The George Washington University). (GU Archives.)

Students gathered in front of the college wall for Field Day in October of 1891. The intramural sporting event was held each year in the late 1800s before intercollegiate sports teams took root on campus. (MLK Library)

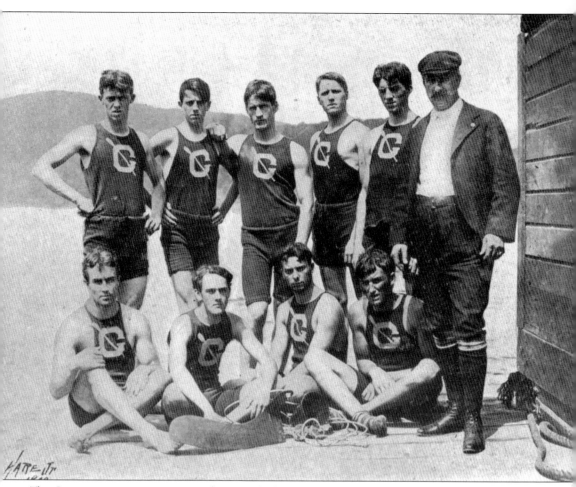

The Georgetown crew team was photographed at Poughkeepsie, New York, 14 years after the founding of the Georgetown Boat Club by students John Agar, T.P. Kernan, and James Dolan in 1876. In a sport that required bright colors so that viewers could distinguish boats from the shoreline, intercollegiate crew teams adopted colors to identify their jerseys and boats. Georgetown's team commissioned a group of Georgetown Visitation students to make blue and gray banners for their boat shells during competition. The colors, symbolizing the reunification of the North and South after the Civil War, were soon widely accepted as Georgetown's official school colors. (GU Archives.)

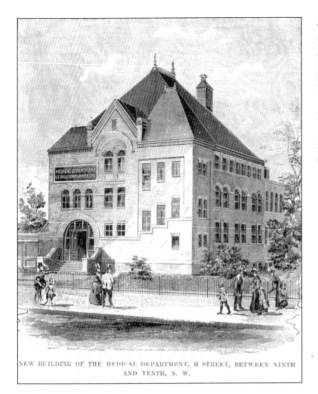

NEW BUILDING OF THE MEDICAL DEPARTMENT, H STREET, BETWEEN NINTH AND TENTH, N. W.

The Medical School Building at 920 H Street, pictured here in 1889, was the first building owned by the Medical School. Immediately prior, the school was housed for 17 years at 10th and E Streets, near the Army Medical Museum. It was not until 1930 that the Medical School relocated to the Georgetown Campus. (GU Archives.)

This building at 506 E Street was the first building owned by the Law School but the fifth that it occupied after its founding in 1870. Opened in November 1891, the *College Journal* described the building as "a marvel of beauty, elegance and convenience." With the new facility, Law School enrollment jumped from 145 students in 1886 to 280 in 1891. The building was expanded numerous times and remained the Law School's home until 1971. (GU Archives.)

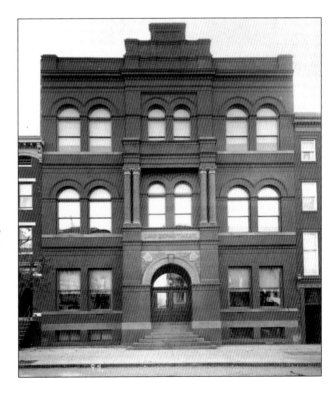

Three

THE NEW CENTURY

The impact of Patrick Healy's bold leadership reverberated on campus well into Georgetown's second century. "Reconstruction" was a theme at Georgetown much as it was a theme for the nation following the Civil War. Healy and his successors saw curricular changes take root, but campus finances were anything but settled as Georgetown struggled to absorb the financial consequences of building Healy Hall.

The era illustrated by this chapter covers additional transformations of the school and campus with the addition of several key buildings beginning in the 1890s, a hospital in 1897, and Ryan Gymnasium in 1906, which allowed for the establishment of additional sporting activities and recreation. Georgetown also consecrated Dahlgren Chapel in 1893 at a time when many students were housed in large open dormitories such as one on the top floor of the Maguire Building. The staff, including cooks, bakers, and front gate guards no doubt watched the newly formed football team play next to Healy Hall in the 1890s, and would later enjoy basketball after the team was formed in 1907. Popular scholastic groups such as the Philodemic Debating Society were documented by photographers in Gaston Hall after the turn of the century, as was the much anticipated unveiling in 1912 of the John Carroll statue in the center campus.

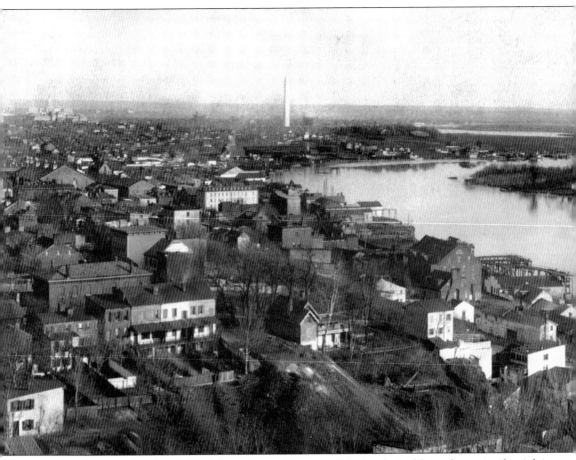

This photograph, taken in 1888 from the south tower of the Healy Building, shows (to the right) the Potomac River docks used to transfer coal from canal barges to river boats. Visible in the foreground is the hilly terrain on which early houses surrounding the campus were built. In the 1870s, a large public works project was undertaken to remove hills and level ravines in the area. This resulted in flatter streets in front of campus, but forced homeowners to install steps that led up or down to the new street elevation—a characteristic of the neighborhood homes that remains today. (GU Archives.)

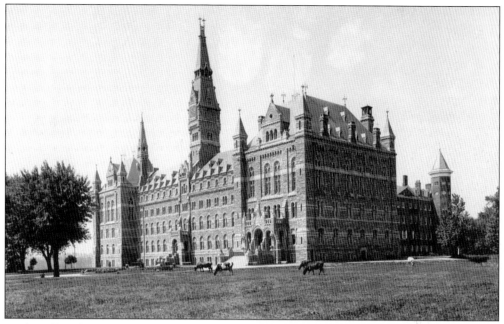

Healy Hall is shown in the company of several cows grazing on what is today Copley Lawn. The exact date of the photograph is unknown; however, the presence of the central and north porches of Healy (completed by 1889) and the absence Ryan Gymnasium (completed in 1906) suggest a turn-of-the-century vintage. (MLK Library.)

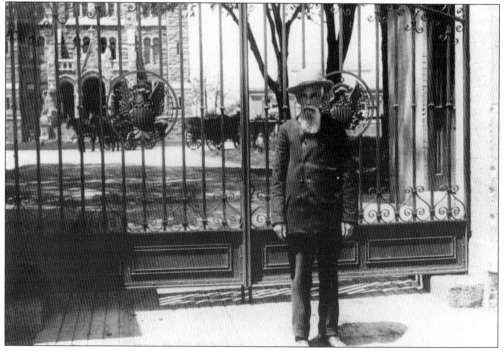

Georgetown gate keeper James "Mr. Mac" McNerhany was photographed at his post in 1910. McNerhany was a Confederate soldier and served as the faithful watchman at Georgetown for many years. (GU Archives.)

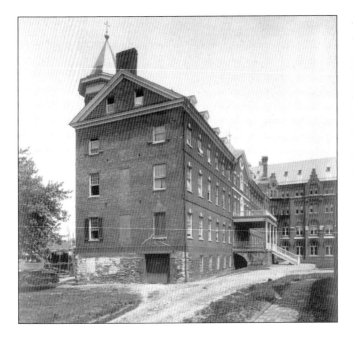

This photograph offers an unusual perspective of the Old North building. The original foundation lines, seen here from the west, became visible when the quadrangle was lowered in 1892 for the construction of Dahlgren Chapel. By 1925, this side of the building would be obscured by the New North building. (GU Archives.)

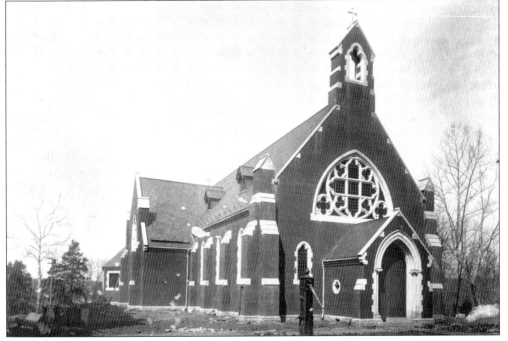

Dahlgren Chapel of the Sacred Heart was photographed in May of 1893, shortly before its consecration in June. The cornerstone was laid on May 19, 1892 for the cross-shaped, English Gothic–style building constructed of red brick and Indiana stone. The chapel was the gift of alumnus John Vinton Dahlgren and his wife, Elizabeth, in memory of their first-born infant son, Joseph, who died of pneumonia. Dahlgren Chapel was the first building on campus funded entirely from outside gifts. (GU Archives.)

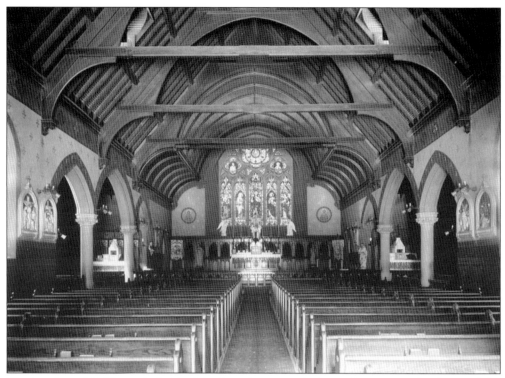

The interior of Dahlgren is finished in Georgia pine, which can be seen in the forms of the huge rafters overhead. All of the chapel's stained-glass windows were made in Munich, Germany under the personal direction of Elizabeth Dahlgren. The central of five stained-glass figures over the altar depicts Jesus showing his Sacred Heart. Over the chapel entrance door is another Munich-made window with script asking passers-by to enter and pray for the Dahlgren family. (GU Archives.)

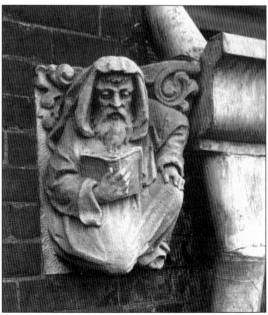

This stone figure is positioned on the south side of Dahlgren Chapel and was sculpted by an itinerant worker named James Earley. Notes by Georgetown Pres. J. Havens Richards, S.J., (1888–1898) recall that Mr. Earley stopped by Fr. Richards's office one morning to ask if there was any work available. The "Monk of Dahlgren," as it came to be known, was carved on-site by Mr. Earley simply to demonstrate his skills as a stone mason, but it was incorporated whimsically into the building's finish. (GU Archives.)

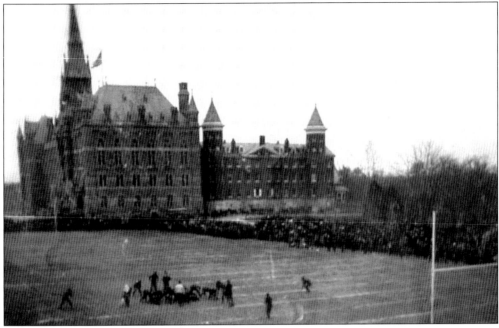

One of Georgetown's first football games against an outside rival was played on the old Varsity Field (what is now Copley Lawn) in 1887 against the Emerson Institute. Georgetown prevailed, 46 to 6. (MLK Library.)

Taken in 1889, this is the first known photograph of the Georgetown football team. A football association took shape at Georgetown in 1874, but the first team was not formed until 1883. The death of Hoya gridiron player George "Shorty" Bahen from football injuries in 1894 led to the cancellation of the sport at Georgetown until 1897, when it was reinstated. (GU Archives.)

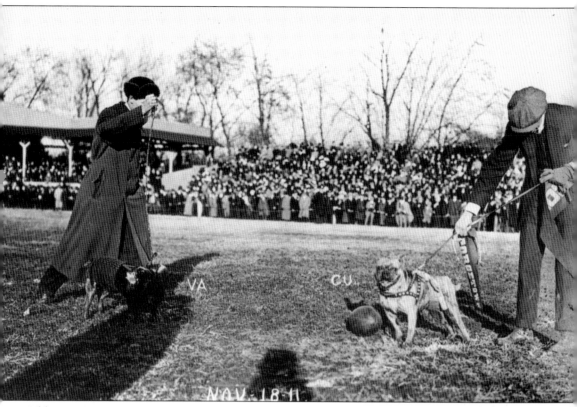

Athletic teams at Georgetown have had canine mascots since at least the late 1800s. Although an English bulldog represents Georgetown today, a Boston bull terrier served as mascot in this 1911 pre-game face-off with the University of Virginia's mascot. The "dogs of Georgetown" have included Boston bull terriers named Stubby and Jazz Bo, and a Great Dane named Butch. Jazz Bo, in the 1920s, was reportedly the first mascot nicknamed "Hoya," and cheers for his halftime show (pushing a football across the field with his nose) most likely influenced reporters to refer to Georgetown's sports teams as the "Hoyas," rather than the "Hilltoppers" as they were previously known. (University of Virginia Archives.)

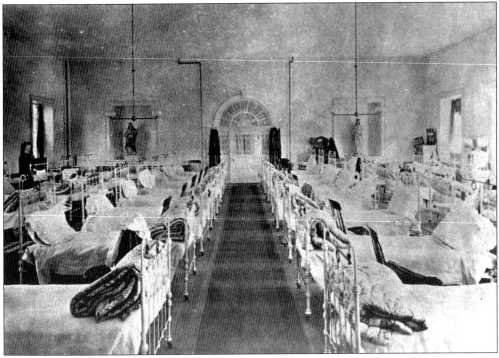

This image portrays an open dormitory on the third floor of the Maguire building in 1898. Traditionally short on space to house students, the open dormitory plan at Georgetown provided an efficient, if Spartan, use of space. (GU Archives.)

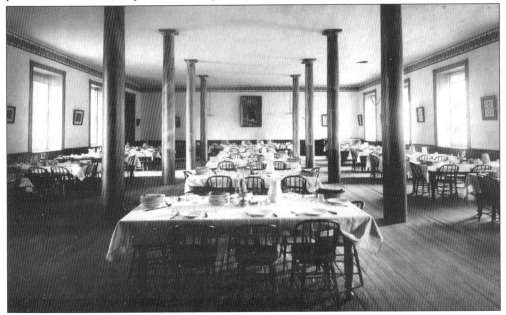

This photograph shows the student dining room (refectory) in Mulledy Hall in 1898. Historian Curran describes student meals eaten in silence, except for "those students who had been assigned to read aloud lines of Latin and Greek poetry memorized as a punishment for disciplinary infractions." (GU Archives.)

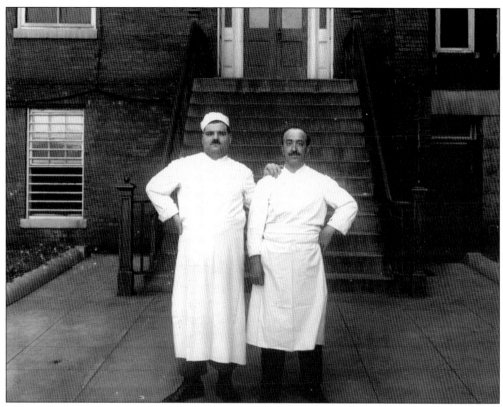

These two cooks, photographed at their job *c.* 1906, were part of the campus staff serving students. (GU Archives.)

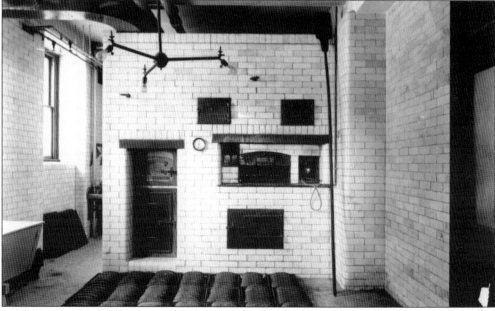

The bakery in the basement of Ryan Hall was photographed *c.* 1906. Facilities like this were maintained on campus to serve the needs of resident students. (GU Archives.)

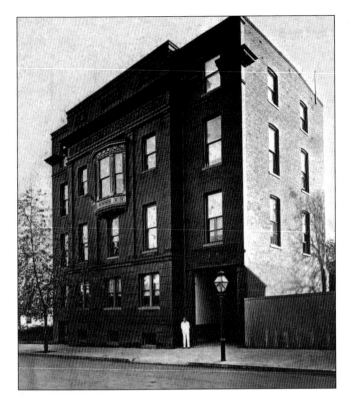

The Medical School faculty felt that integrating an operating hospital into the curriculum would greatly enhance the school's standing, and in early 1897, plans were drawn to build Georgetown's first hospital on land donated by banker Francis E. Riggs at 35th and N Streets. (GU Archives.)

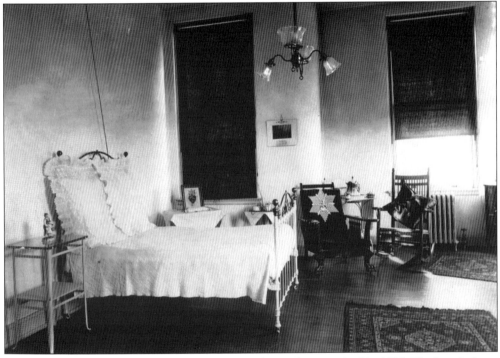

This single patient's room at Georgetown Hospital was photographed in 1906. The hospital was segregated at the time, but received patients "regardless of race, creed, or color." (GU Archives.)

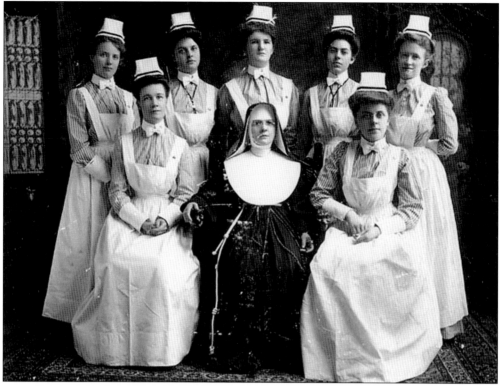

Pictured here in 1906 are the first graduates of the Georgetown Training School for Nurses. Founded in 1903 and originally run by the Sisters of Saint Francis, the School of Nursing and Health Sciences, as it was later named, trained nursing staff for the growing Georgetown Hospital. (GU Archives.)

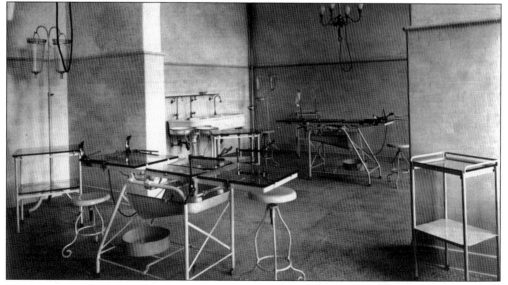

This photograph shows the operating room at Georgetown Hospital in 1906. The *College Journal* at the time described the white-tiled operating room and the glass operating tables of the "latest design and equipped with all the modern improvements." (GU Archives.)

Robert Collier graduated from Georgetown with a Bachelor of Arts degree in 1894. While at Georgetown, Collier was editor-in-chief of the student periodical, the *College Journal,* and wrote the words to Georgetown's official college song, "Sons of Georgetown, Alma Mater." (GU Archives.)

Condé Naste, an 1894 graduate of Georgetown, first worked as business manager at *Colliers Weekly* (thanks to his college roommate Robert Collier). Naste went on to found the publishing empire that bears his name. (GU Archives.)

Before organized athletic teams emerged on campus, handball was a popular recreational activity for students. Erected in 1897, the "junior students' handball alley" was positioned on the site of today's Village A dormitory. (GU Archives.)

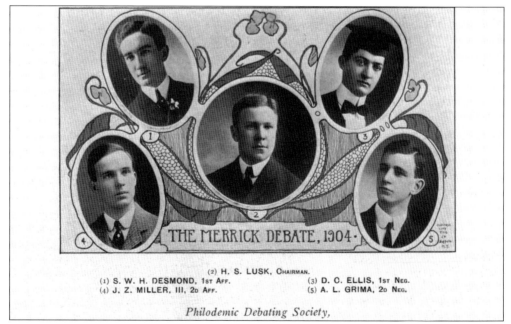

(2) H. S. LUSK, Chairman.
(1) S. W. H. DESMOND, 1st Aff. (3) D. O. ELLIS, 1st Neg.
(4) J. Z. MILLER, III, 2d Aff. (5) A. L. GRIMA, 2d Neg.

Philodemic Debating Society,

These competitors in the Philodemic Debating Society's Merrick Debate, held in Gaston Hall in 1904, responded to the proposition: "Resolved the true theory of economics is that the machinery of production must belong to the people in common." (GU Archives.)

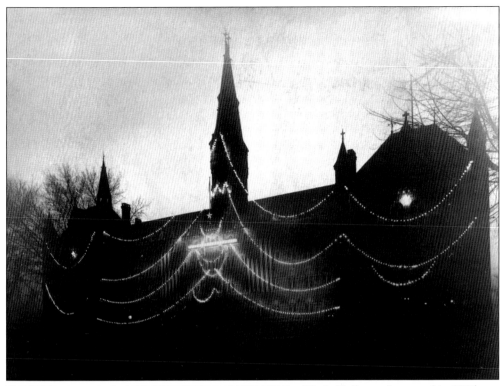

Healy Hall was decorated in 1904 with bright lights for the Feast of the Immaculate Conception. The Sodality led annual celebrations on the December 8th Feast Day, owing to their devotion to the Immaculate Conception of Mary. (GU Archives.)

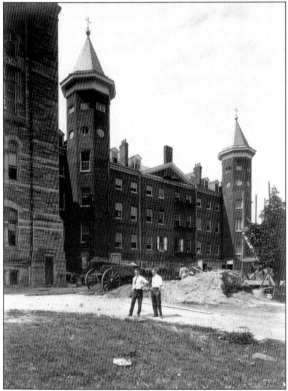

This turn-of-the-century photograph shows Ryan Gymnasium under construction. Somewhat incidental to the subject of this photograph are the wide-open windows of Old North and Healy Hall, both probably stifling hot in summertime. Summer heat was surely a factor in activities at Georgetown before air conditioning. In fact, minutes from the 1894 Annual Meeting of Alumni made note of the "flies and heat" that plagued their June meeting. (GU Archives.)

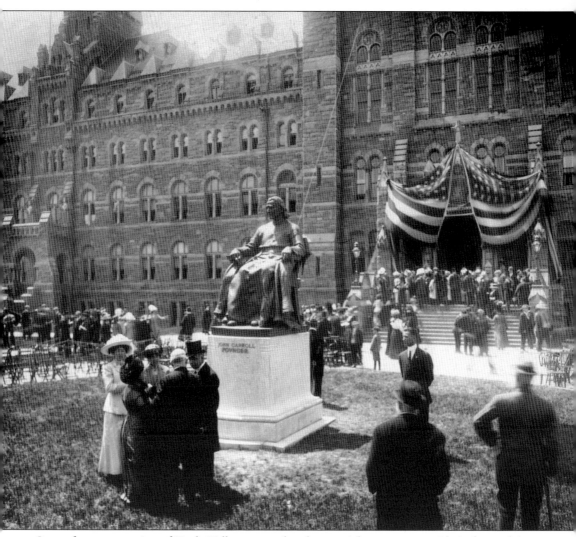

Soon after construction of Healy Hall was completed, a special area was set aside in front of the building for a statue honoring John Carroll. Alumni raised funds to commission a bronze statue, which was unveiled in 1912. This photograph was taken soon after Chief Justice Edward Douglas White concluded the dedication ceremony. (GU Archives.)

GEORGETOWN UNIVERSITY,
WASHINGTON, D. C.

Financial Acc't 1908-09

Receipts :

Board & Tuition — 79,338.56
Interest — 1,275.82
Gift - foundation for medal) 1000.
Perquisites - 5523.50
Personal gifts 591.15
F. C" Salary — 100.
Other Various Sources — 527.04
 88,356.07

Expenses -
.. 95,547.19

Deficit - $7,191.12

Georgetown's heavy reliance on tuition to cover operating expenses has a long history, as does the need for deficit spending. Indeed, the absence of a sizable endowment has consistently, and sometimes almost fatally, challenged the school. (GU Archives.)

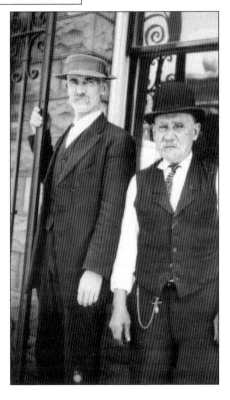

In 1914, the college police force included Capt. Johnson Higgs (left), who served as the night watchman, and John Gartland (right), who served as the day relief. Gartland worked at Georgetown for over 40 years. (GU Archives.)

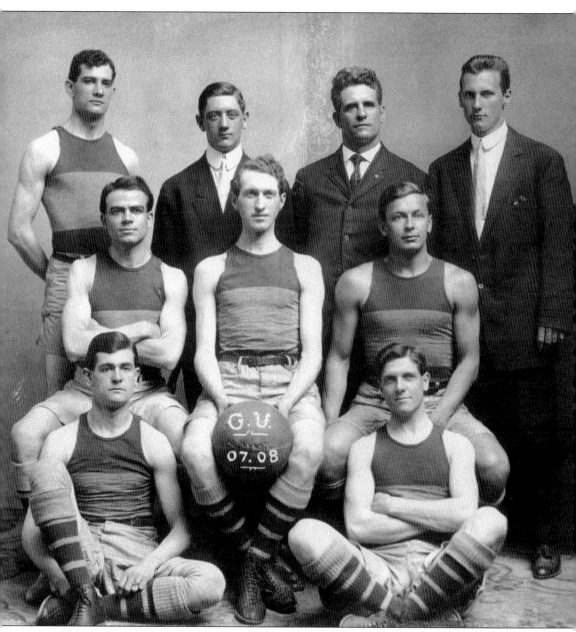

The first intercollegiate basketball team was formed at Georgetown in 1907. The first game was played against The George Washington University in Ryan Gymnasium; Georgetown scored only eight baskets and was defeated. (GU Archives.)

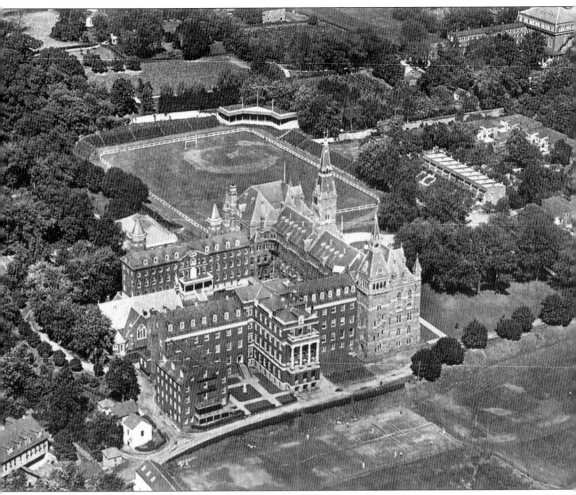

This seldom-seen image from 1918 is the first aerial view of the campus and was taken by a United States Army airplane. When the photograph ran in the May 1920 issue of the *London News,* the headline declared Georgetown "The Versailles of America." At the time, the campus was almost exclusively centered around the quadrangle. New North was not yet built, but the roof of Ryan Gymnasium is visible as are the ball field and grandstands. Tennis courts occupy the present site of Village A and Lauinger Library. (GU Archives.)

Four

THE WORLD WARS
AND GLOBAL FOCUS

Perhaps not since the Civil War was Georgetown's history so intertwined with national history as during the period from 1920 to 1960. Two world wars, an economic depression, and America's emergence as a global power were all defining events for Georgetown.

The illustrations included in this chapter concentrate on the rapid building campaign undertaken by the University, seemingly halted only for short periods while students prepared and participated in both World Wars. Under the leadership of Pres. W. Coleman Nevils, S.J., major campus buildings were erected on the open land once reserved for sporting events and cadet training for World War I. From the addition of New North in 1927 through the construction period of Washington's premier medical building in 1930, and from the consideration of a large sporting stadium to the completion of Copley Hall in 1930 and the White-Gravenor building three years later, the campus emerged in sync with Georgetown's growth as a university. World War II again interrupted activities as students training on campus were sent to theaters of war on all fronts. However, in the following decades, a need for additional student housing and classroom space was met, along with the addition of the Georgetown Hospital, completed in 1948. McDonough Gymnasium was completed in 1951, and the School of Foreign Service moved into a new building in 1958, just a year before students moved into the New South dormitory. Additional classroom space and laboratories were created by the completion of the Reiss Science Building in 1962, after what must have seemed like a never-ending expansion of Georgetown's facilities and curriculum.

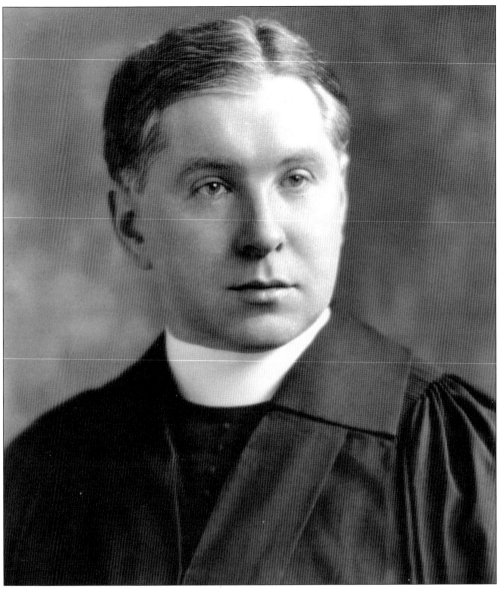

Edmund A. Walsh, S.J., founded the School of Foreign Service at Georgetown in 1919, the first of its kind in the United States. Although Georgetown had an international character from its inception, the School of Foreign Service (later named for Walsh) elevated foreign service to a vocation worthy of formal training. From the Walsh School also emerged the Institute of Languages and Linguistics (1949) and the McDonough School of Business (1957). Incidentally, Walsh was known incorrectly in the 1950s as "the voice who whispered in McCarthy's ear," suggesting that Walsh sold Sen. Joseph McCarthy on the idea that Communist agents had infiltrated American life, especially in the government and entertainment industry. (GU Archives.)

The School of Foreign Service was housed initially in an annex of the Law School's facilities at 6th and E Streets, pictured here. In 1932, the School of Foreign Service was moved to Healy Hall where it remained until 1958 when the Walsh Building was erected on the East Campus. (GU Archives.)

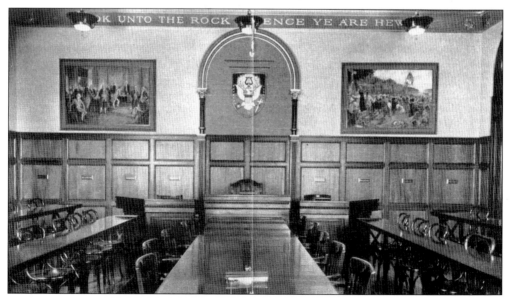

Final oral examinations were once held in the Constitution Room in Healy Hall. The murals in the room depict the signing of the Declaration of Independence in 1776 and the Pact of Peace and Friendship between Native Americans and the Maryland colonists in 1634. The figure imparting the benediction in the latter mural is Andrew White, the Jesuit missionary who accompanied the Lord Baltimore Colony to Maryland. (GU Archives.)

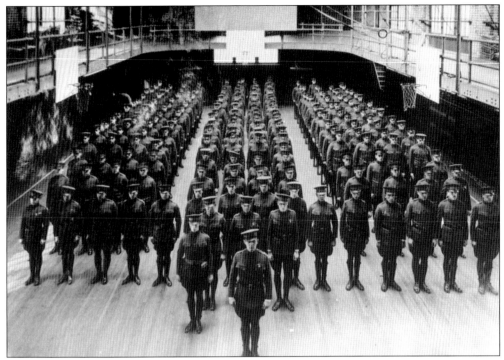

With the outbreak of World War I, Georgetown formed a 500-member Cadet Corps in the spring of 1917. Some members of the Corp are seen here utilizing Ryan Gymnasium for training and exercise before joining the war effort themselves. The Student Army Training Corps (SATC) under War Department control supplanted both Naval and Infantry Cadet Corps units in September of 1918. (GU Archives.)

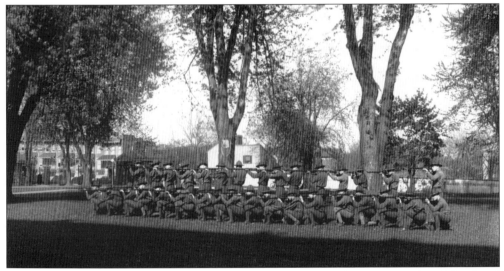

Following the Armistice ending World War I in November 1918, the SATC was demobilized and replaced by the Reserve Officers Training Corp (ROTC) program. This ROTC squad was photographed while at rifle practice on Healy Lawn. Overall, 2,378 Georgetown men served in World War I and 53 lost their lives in the service. (GU Archives.)

Standing in front of the western wall of Old North, Georgetown Pres. Charles W. Lyons, S.J., (1924–1928) breaks ground for the New North building in 1925. New North, which originally had a rifle range located in its basement, served as a dormitory for more than 60 years and was the last building ever added to the Quadrangle. Early maps of the campus indicate that a tailor and shoe-maker shop as well as a long row of outdoor "privies" made of wood were once on the same site. (Underwood & Underwood/GU Archives.)

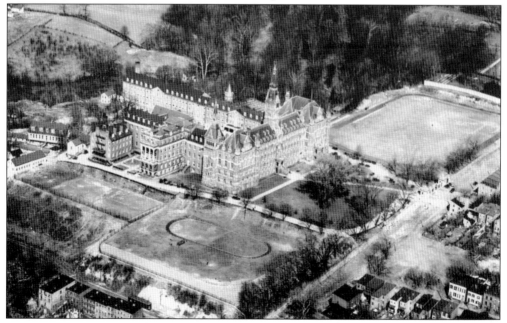

When this 1927 aerial photograph was taken, New North was the newest building on campus. From this time forward, the Quadrangle area would remain virtually unchanged, but the proximity of athletic fields to the nucleus of campus and the rustic majesty of the campus Walks would change substantially as mid-20th century building campaigns transformed the campus. (GU Archives.)

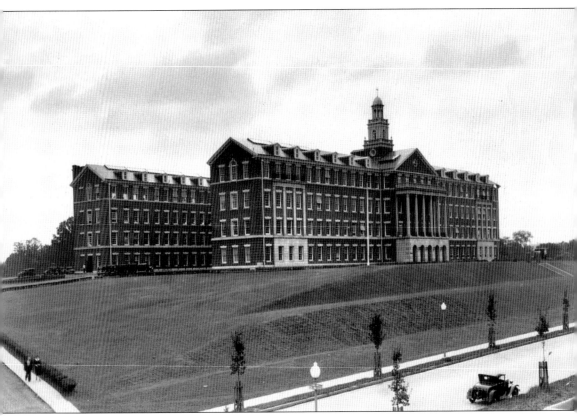

Completed at a cost of $2.5 million in 1930, the Medical School building was constructed at the far northwest corner campus. Early plans called for the new building to be located on N Street between 36th and 37th Streets. Although this strategy would have positioned the school adjacent to the original hospital at 35th and N Streets, Pres. Coleman Nevils, S.J., felt that future development of the Medical School would be too constrained if located on a neighborhood street. Thus the new building was placed in a remote location of the campus where extensive facilities expansion could take place. (GU Archives.)

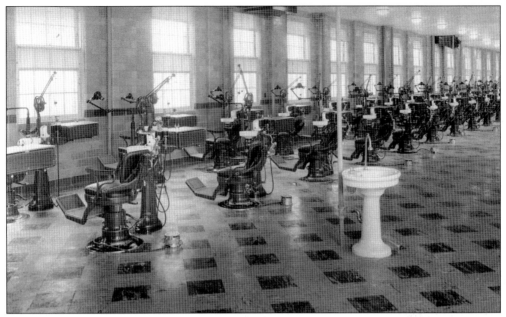

This 1930 photograph shows a multitude of "Ritter" equipment in the Dental Infirmary, part of the new Medical School building. Georgetown's Dental School began in 1901 when the Washington Dental School was acquired and integrated into Georgetown's Medical School. A decision to close the Dental School—the largest private dental school in the nation at the time— was made in 1987 because of a looming "financial disaster" and fears that the school's quality would deteriorate as the number of students going into dentistry plummeted nationwide. (Lect Brothers/GU Archives.)

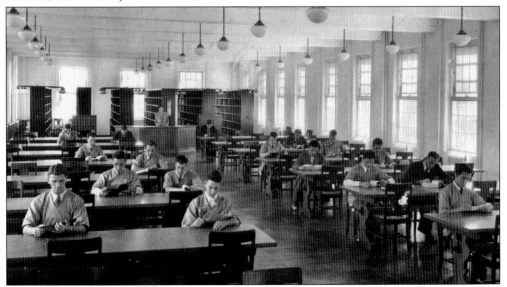

This photograph shows the Medical Library shortly after the Medical School building opened in 1930. The original Medical School Library was founded in 1912 by Dr. George M. Kober, dean of the Medical School. The library's first texts were donated from doctors on the staff and from the personal library of Dr. Kober and United States Surgeon General Dr. John B. Hamilton. (GU Archives.)

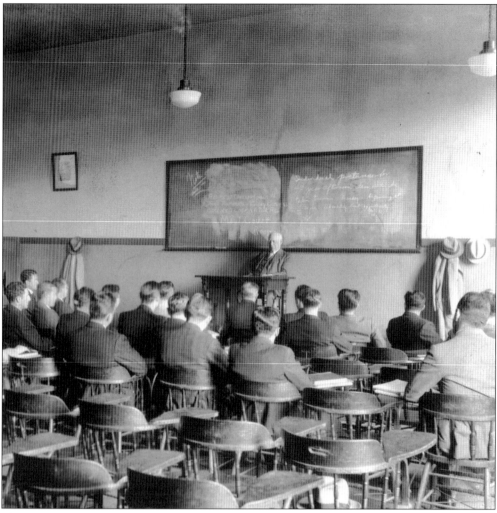

This Law School class, pictured in 1921, was led by Prof. Charles Keigwin, one of the first two faculty members hired for full-time teaching. The blackboard advises students that pictures for the fourth-year afternoon class will be taken Tuesday. (GU Archives.)

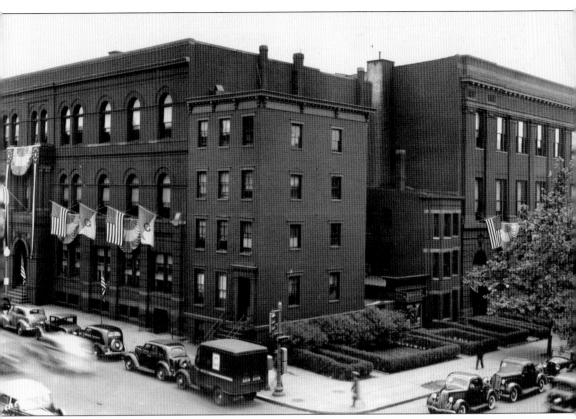

The building at left, decorated with bunting for Georgetown's 150th anniversary in 1939, is the original 1891 portion of the Law School building at 506 E Street. The townhouse seen at the corner was utilized as a dormitory for law students, and the Law Annex Building (seen at the far right) was the original home for the School of Foreign Service. The complex remained in use until 1971 when McDonough Hall was built on New Jersey Avenue. (Tenschert Studio/GU Archives.)

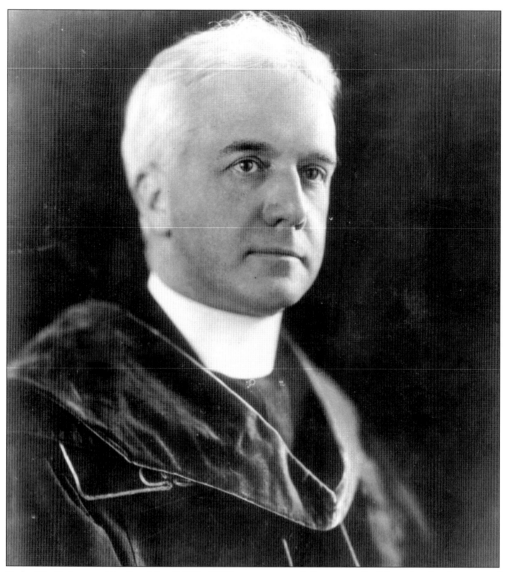

Pres. W. Coleman Nevils, S.J., (1928–1935) was one of the great builders in the history of Georgetown. As noted by alumnus William McEvitt in his book *The Hilltop Remembered*, Nevils's "pile drivers and excavators were soon making shambles out of Old Varsity Field and its picturesque grandstand. Here [Nevils] proceeded to erect a 'Greater Georgetown.'" The "Greater Georgetown" to which McEvitt refers included the Andrew White Memorial Quadrangle, named after the pioneer Jesuit who arrived at Southern Maryland with Leonard Calvert in 1634. (Underwood & Underwood/GU Archives.)

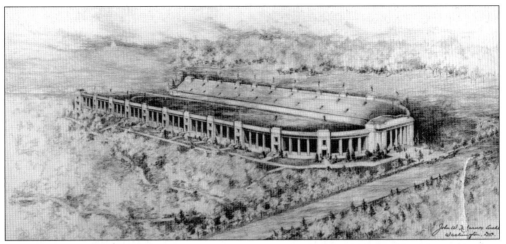

Before Nevils became president in 1928, plans were underway to erect a sports stadium on Varsity Field (what is now Copley Lawn). These 1922 drawings anticipate the scope of the project before it was scrapped in favor of building much-needed dormitory, classroom, and laboratory space. (GU Archives.)

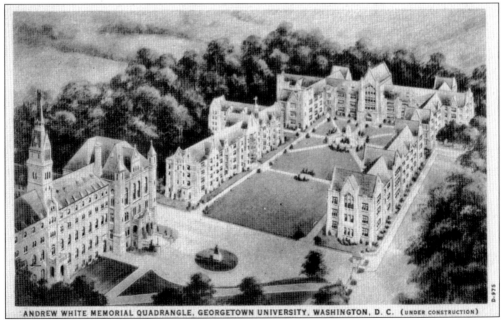

ANDREW WHITE MEMORIAL QUADRANGLE, GEORGETOWN UNIVERSITY, WASHINGTON, D. C. (UNDER CONSTRUCTION)

Nevils's vision of the Andrew White Memorial Quadrangle was never fully realized. Plans for a third building facing Copley Hall were not executed due to budget constraints. Elsewhere on campus, Nevils transformed the Coleman Museum on the second floor of Healy Hall into the President's Office and the Hall of Cardinals. (MLK Library.)

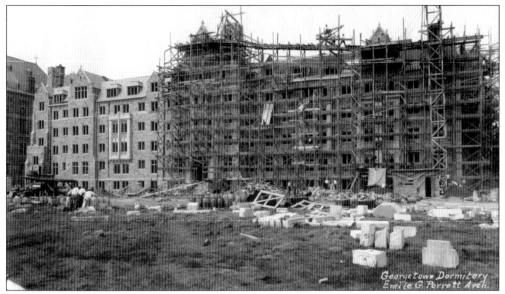

When Copley Hall was under construction in 1930, the Francis Scott Key Bridge was being erected across the Potomac River in place of the Aqueduct Bridge. Copley architects saw the weather-stained foundation stones from the old bridge being discarded and bought them immediately to create the new building's facade. Thomas Copley, S.J., for whom the building is named, is credited with drafting the "Act for the Toleration of Religion," the first of its kind in North America, which was enacted in 1642. (Commercial Photo Co./GU Archives.)

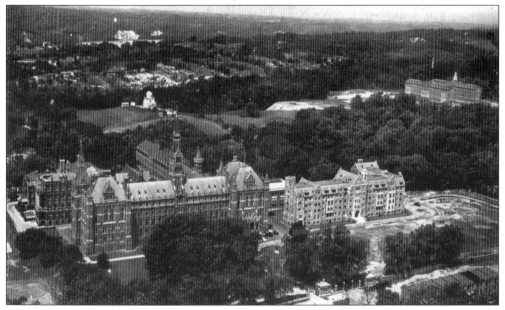

This 1931 aerial view by Albert Stevens appeared in *National Geographic* magazine. The photograph shows the newly finished Copley Hall, neatly aligned next to Healy Hall and facing the city. In the upper right corner is the Medical School building, completed in 1930 and positioned at the far northwest corner of the campus. Some years beforehand, a large a tract of land was sold across from the Medical School site to finance debts incurred during the construction of Healy Hall. (MLK Library.)

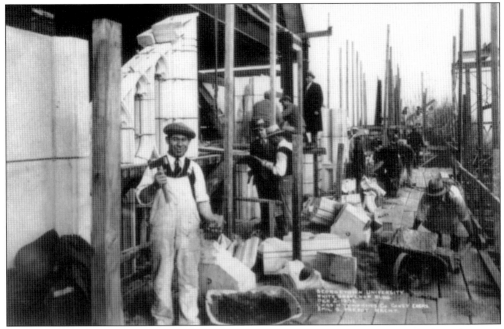

Photographed in 1932, stone masons are seen completing the facade of the White-Gravenor building. In a 1932 letter to President Herbert Hoover, Pres. Coleman Nevils, S.J., explained that the White-Gravenor project would begin early to provide unemployment relief for about 400 men during the nation's "economic emergency." Some believe that initiating the White-Gravenor project early, before funding was secured, caused a financial stress so great that plans for a third building to form a Quadrangle were never realized. (GU Archives.)

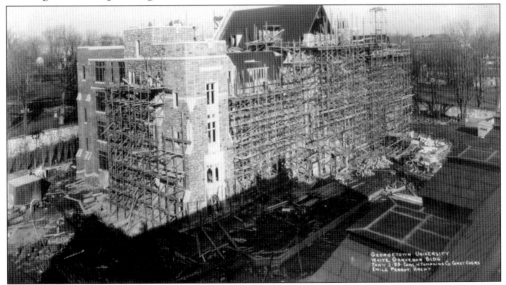

Conforming to the neo-Gothic style of Copley Hall, the White-Gravenor building was completed in 1933. The building takes its name from Fr. Andrew White and Fr. Latham Gravenor, two of the first Jesuits to come to America with the Lord Baltimore colonists in 1634. White-Gravenor was built to house offices for the dean of the College of Arts and Sciences as well as 20 classrooms, fireproof vaults for the university archives, and (at one point) a student cafeteria. (GU Archives.)

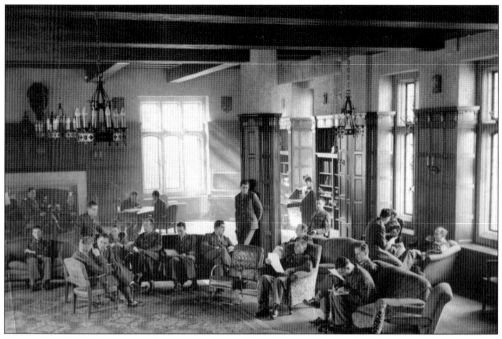

These World War II–era students are pictured in 1944 in the senior class reading lounge of Copley Hall. Seen above the fireplace at left is the mounted head of a buffalo shot in 1872 by Col. William Cody, better known as "Buffalo Bill." The trophy was donated to Georgetown by an unnamed alumnus. (Sidney R. Bayne/GU Archives.)

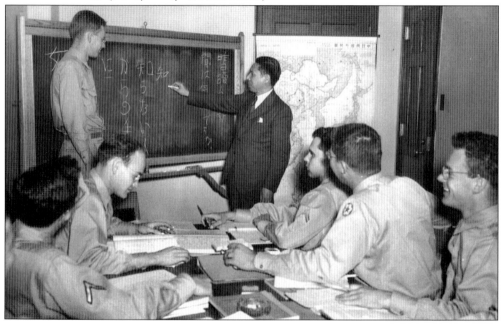

Georgetown Prof. Chinting Stien was photographed in 1942 teaching Japanese to Georgetown student-soldiers awaiting their draft into World War II. That same year, the School of Foreign Service added both Japanese and Dutch to the curriculum, anticipating that speakers of both languages would be much needed during and after the war. (Sidney R. Bayne/GU Archives.)

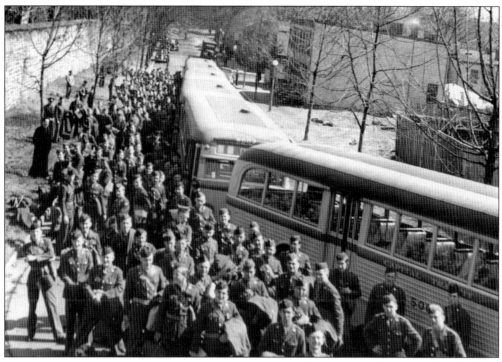

This photograph, showing student-soldiers boarding buses at Georgetown for military conscription, appeared in the January 1944 issue of *Jesuit Seminary News*. Two years earlier, Georgetown began offering several 12-week condensed classes to accommodate the hurried needs of servicemen about to join the war effort overseas. (MLK Library.)

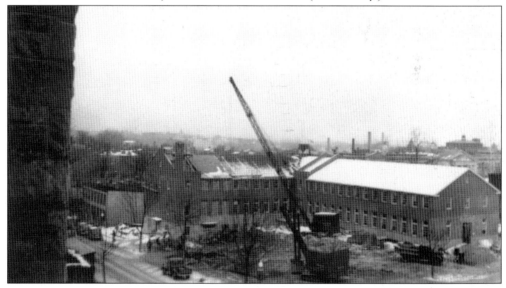

Poulton Hall is pictured here during its "reconstruction" on campus in 1947. Following the war, thousands of temporary wood-frame military buildings were disassembled by the government and made available for use through the College Building Program of the Federal Works Agency. Poulton Hall originally housed TNT at the Susquehanna submarine depot near Williamsport, Pennsylvania. (GU Archives.)

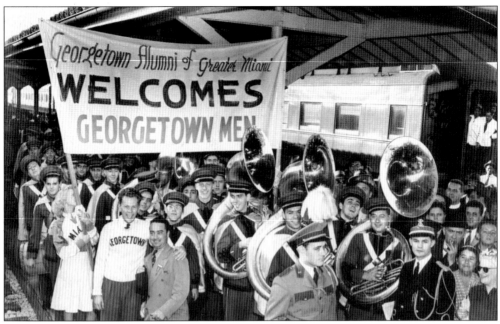

The Georgetown Alumni of Greater Miami welcomed Georgetown players and the band to the Seventh Annual Orange Bowl Classic on January 1, 1941. The Hoyas were depleted by injuries and lost to the unbeaten Mississippi State Maroons, 14 to 7. An estimated 37,000 spectators (a record crowd at the time) attended the game. (GU Archives.)

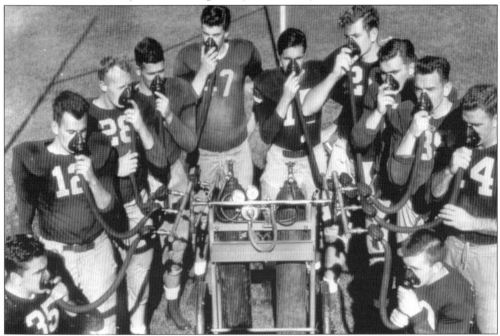

Georgetown football players were photographed in 1946 using an oxygen dispensing go-cart aimed at "pepping up weary players." Football was discontinued in 1951 under Pres. Hunter Guthrie, S.J., (1949–1952), who felt the sport had "soared completely out of the scale of educational values." Intercollegiate play resumed in 1964. (GU Archives.)

Alfred C. "Al" Blozis was one of Georgetown's greatest athletes—setting 28 records in football and track, and twice winning the National Shot-put Championship in 1941 and 1942. Tragically, Blozis died at age 26 fighting in the Vosges Mountains of France in January 1945. He was inducted into the College Football Hall of Fame in 1986. (GU Archives.)

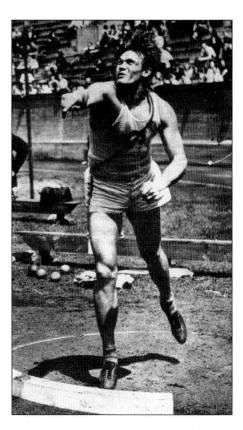

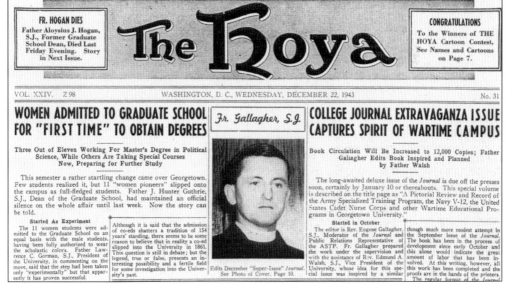

The Hoya

VOL. XXIV. Z 98 WASHINGTON, D. C., WEDNESDAY, DECEMBER 22, 1943 No. 31

WOMEN ADMITTED TO GRADUATE SCHOOL FOR "FIRST TIME" TO OBTAIN DEGREES

Three Out of Eleven Working For Master's Degree in Political Science, While Others Are Taking Special Courses Now, Preparing for Further Study

This semester a rather startling change came over Georgetown. Few students realized it, but 11 "women pioneers" slipped onto the campus as full-fledged students. Father J. Hunter Guthrie, S.J., Dean of the Graduate School, had maintained an official silence on the whole affair until last week. Now the story can be told.

Started As Experiment

The 11 women students were admitted to the Graduate School on an equal basis with the male students, having been fully authorized to wear the scholastic colors. Father Lawrence C. Gorman, S.J., President of the University, in commenting on the move, said that the step had been taken only "experimentally" but that apparently it has proven successful.

Although it is said that the admission of co-eds shatters a tradition of 154 years' standing, there seems to be some reason to believe that in reality a co-ed slipped into the University in 1861. This question is still in debate; but the legend, true or false, presents an interesting possibility and a fertile field for some investigation into the University's past.

Jr. Gallagher, S.J.

Edits December "Super-Issue" Journal. See Photo of Cover, Page 10.

COLLEGE JOURNAL EXTRAVAGANZA ISSUE CAPTURES SPIRIT OF WARTIME CAMPUS

Book Circulation Will Be Increased to 12,000 Copies; Father Gallagher Edits Book Inspired and Planned by Father Walsh

The long-awaited deluxe issue of the *Journal* is due off the presses soon, certainly by January 10 or thereabouts. This special volume is described on the title page as "A Pictorial Review and Record of the Army Specialized Training Program, the Navy V-12, the United States Cadet Nurse Corps and other Wartime Educational Programs in Georgetown University."

Started in October

The editor is Rev. Eugene Gallagher, S.J., Moderator of the *Journal* and Public Relations Representative of the ASTP. Fr. Gallagher prepared the work under the supervision and with the assistance of Rev. Edmund A. Walsh, S.J., Vice President of the University, whose idea for this special issue was inspired by a similar

though much more modest attempt in the September issue of the *Journal*. The book has been in the process of development since early October and this alone would indicate the great amount of labor that has been involved. At this writing, however, all this work has been completed and the proofs are in the hands of the printers. The regular format of the *Journal*

In 1943, *The Hoya* ran a headline announcing the admission of women to the Graduate School. Georgetown Pres. Lawrence Gorman, S.J. (1942–1949) described the "experimental" action as a "wartime concession." As a result, 11 women enrolled in graduate studies on an equal status with men. (*The Hoya*.)

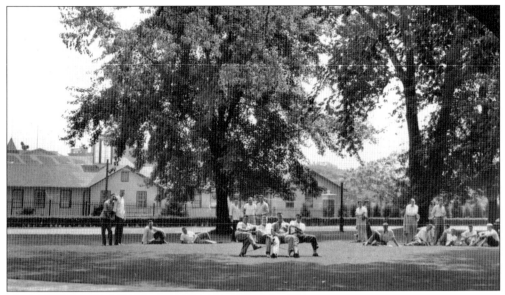

Students relax on Healy Lawn in 1947, with the School of Foreign Service annex buildings visible across 37th Street in the background. Following World War II, 75 percent of students in the School of Foreign Service were veterans. During the war, the school reorganized its curriculum—adding summer terms and shortening vacations—to allow students to complete a college degree before military induction. (GU Archives.)

Following World War II, Georgetown's campus was filled with former soldiers seeking education under the Servicemen's Readjustment Act—otherwise known as the "GI Bill." To meet the urgent demands for dormitory and teaching space, the school obtained two buildings from the naval base on Solomons Island, Maryland, and hastily erected them on the site of today's Alumni Square. The buildings were partially destroyed by arsonists in 1963 during campus protests against the Vietnam War. (MLK. Library)

School of Foreign Service founder Edmund A. Walsh, S.J., is pictured with Army Gen. Douglas MacArthur during a visit to Japan in 1948. Walsh traveled to Tokyo after serving as a consultant for the International Military Court in Nuremberg, Germany. General MacArthur—who favored the spread of Christianity in post-war Japan—facilitated Walsh's visit, which included an assessment of Jesuit missions in that country. (Signal Corps-U.S. Army/GU Archives.)

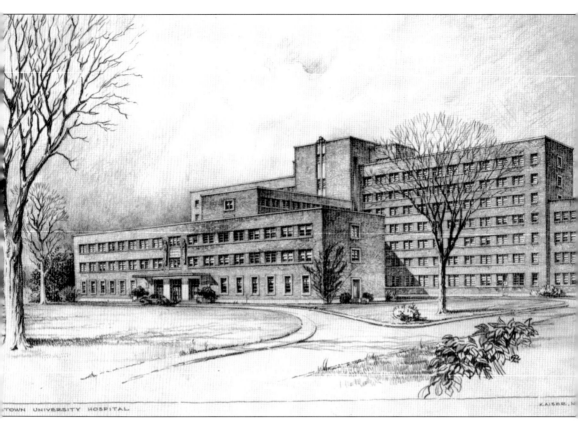

TOWN UNIVERSITY HOSPITAL

This rendering of the Georgetown hospital building was submitted in 1944 by the architectural firm of Kaiser, Neal and Reid. Completed in April of 1948, the facility increased patient capacity to 407. Major funding for the building came with the passage of the Lanham Act of 1944, which provided grants through the Federal Works Administration. President Roosevelt approved a grant of $3.6 million, and the building was later dedicated in his honor. (GU Archives.)

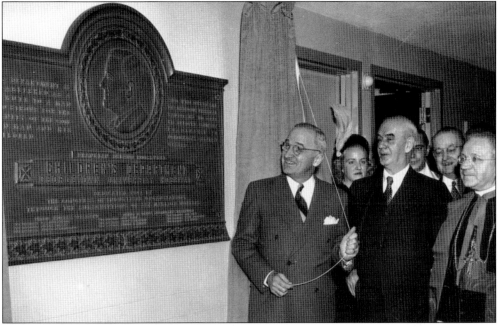

President Harry Truman is seen here unveiling a dedication plaque in the children's wing of the new hospital building on December 1, 1947. (GU Archives.)

Taken as part of a promotional photographic essay when the new hospital opened in 1948, three nurses care for this patient in what was then a state-of-the-art facility. Since its opening, the hospital has been greatly expanded with over 60 renovations and additions, including the Lombardi Cancer Center (opened in 1982) and has maintained its status as a leading research, teaching, and hospital care center. (GU Archives.)

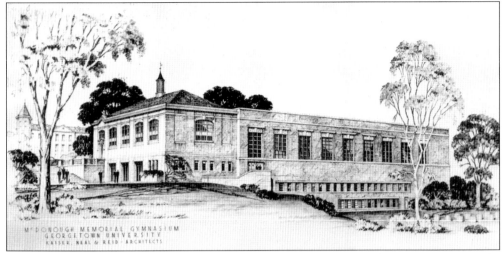

Architects submitted drawings in 1948 for a major expansion of the 1906 Ryan Gymnasium. The sketches depicted the new building as an extension of Ryan, and fund-raising for the project had already begun before the plan was scrapped in favor of a free-standing building (McDonough Gymnasium) at the far western edge of the campus. (MLK Library.)

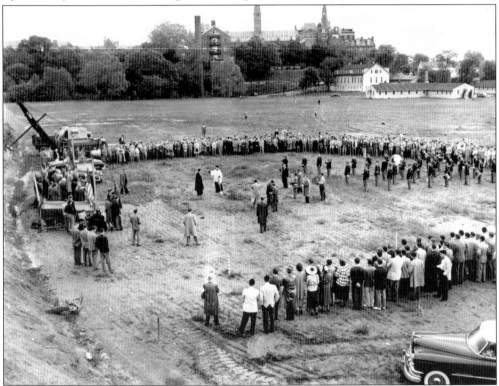

The groundbreaking for McDonough Gymnasium took place in 1950. The gym was named for Vincent "Fr. Mac" McDonough, S.J., director of athletics at Georgetown for 13 years. The photograph is notable for the perspective it provides of the heavily wooded area of campus— vestiges of the campus Walks that would be eliminated soon thereafter for additional mid-century building projects. (GU Archives.)

96

From left to right, track team members Carl Joyce, Dick Doyle, Jim Nawn, and Bob Cusard are pictured in 1950 awaiting the starting gun on a wooden track in front of Healy Hall. A year earlier at Madison Square Garden, the Georgetown one-mile relay team established the fastest time in the country for the 1949 season. Their new record stood for only a half an hour, however, for in the Metropolitan one-mile relay, New York University defeated Manhattan in 3:20.2, securing the fastest time by just two-tenths of a second. (GU Archives.)

A women's athletic association was formed at Georgetown in 1952 and was initially limited to nursing students who played intramural basketball. In 1956, the first women to earn varsity letters were Skippy White (NUR '57, pictured far left) and Carol Bloise (NUR '58, pictured far right), both of whom won spots on the men's sailing team. (*Ye Domesday Book*.)

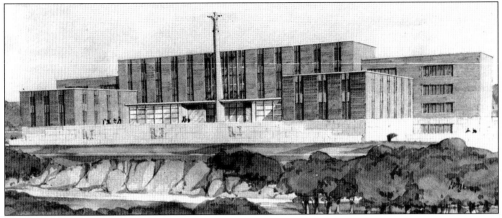

In 1953, plans were developing for a new building to house the School of Foreign Service. Early drawings were based on notes by the school's founder, Edmund A. Walsh, S.J., who envisioned an imposing structure jetting out toward the Potomac River from a location at the southwest corner of the campus. Father Walsh's notes described a statue of Christ high atop the building that would be a national attraction for visitors to Washington, D.C. (MLK Library.)

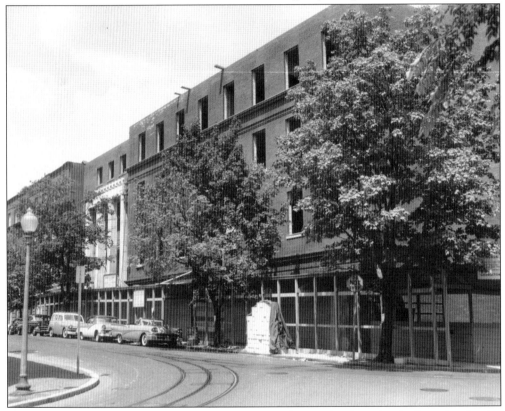

Financial realities substantially diminished Walsh's ambitions for the School of Foreign Service building. Designs for the structure were scaled back, and its location was moved to 36th and Prospect Streets. Shown here nearing completion in 1958, the new building, later named for Walsh, housed the School of Foreign Service, the Institute of Languages and Linguistics, and the School of Business Administration until the 1980s. (MLK Library.)

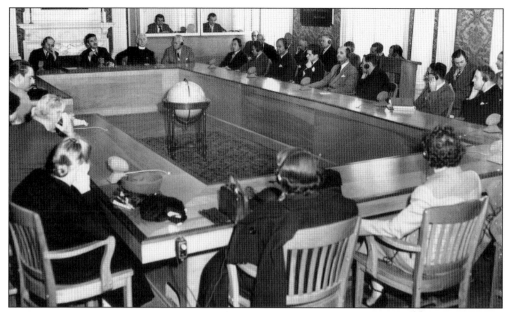

This image, taken on November 23, 1949, shows students from the Institute of Languages and Linguistics learning to use United Nations–like translation equipment. The Institute, which opened in October of 1949, was a first in United States education and addressed American students' "debilitating ignorance of foreign languages." (GU Archives.)

The School of Business Administration (later the McDonough School of Business) was a department of the School of Foreign Service until 1957. Classes in global business and trade were part of the earliest Foreign Service curriculum, reflecting American views that international commerce was the central concern of the United States in foreign affairs. (GU Archives.)

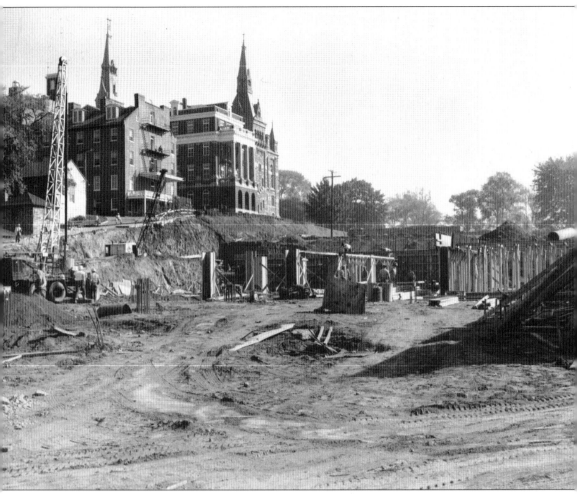

This photograph shows the early stages of construction for the New South dormitory and cafeteria, opened in 1959. Following the launch of the first "Sputnik" by the Soviet Union in 1957, a new wave of federal funding for higher education became available. In light of this, Georgetown requested and received federal funding for a new dormitory but was limited to a "no frills" building with modern architecture. Later attempts to make New South more compatible with the rest of the campus were rejected by the District of Columbia Fine Arts Commission because "New South has become part of the historic skyline of Georgetown." (MLK Library.)

Comedian Bob Hope was keynote speaker at the 1961 ground-breaking ceremony for the Reiss Science Building. Constructed at a cost of $4.25 million, the seven-level building added 132,000 square feet to the facilities of the university's chemistry, physics, biology, mathematics, and seismology departments. The building was named for Raymond H. Reiss, a New York manufacturer and former chairman of the University Board of Directors. (MLK Library.)

This student was photographed washing the face of the John Carroll statue as part of a hazing ritual. Other hazing activities at the time included dusting the 175,000 volumes of books in the Riggs library, polishing the porch of Old North, or walking across campus as a call boy announcing, "Telephone call for John Carroll!" (MLK Library.)

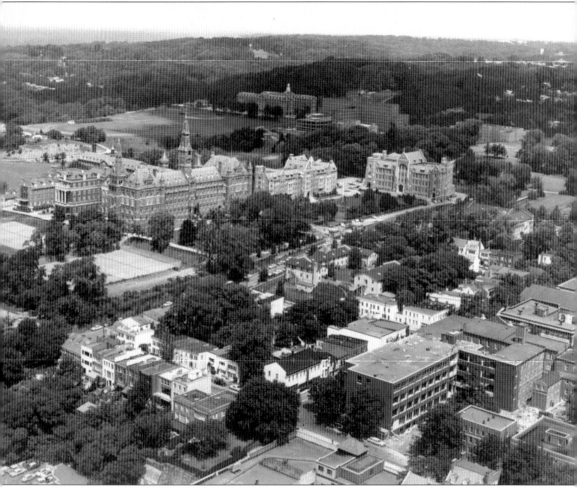

This aerial view of campus is undated, but unfinished construction of the Walsh Building on the East Campus (lower right) and the absence of the Reiss Science building (adjacent to White-Gravenor) dates the photograph to *c*. 1960. (GU Archives.)

Five

TOWARD A THIRD CENTURY

The years that immediately preceded Georgetown's 200th anniversary bear interesting parallels to the years that prefaced its 100th anniversary. Ironically, a Healy served as president during both eras, and each period was marked by substantial transition and strong leadership. The 19th-century Patrick Healy had aspirations for Georgetown to become a university. The 20th-century Timothy Healy had aspirations of perfecting the earlier Healy's vision. Before the second Healy, however, there was Edward B. Bunn, S.J. (1952–64), Gerard J. Campbell, S.J., (1964–69), and Robert J. Henle, S.J., (1969–76). Across these presidents' terms span the images of this chapter.

The years 1960 to 1989 witnessed student activities and building campaigns that were both controversial and historic. The practice of student hazing was turned from one of humiliation to community service, at a time when popular student gathering spots included the Hilltop Café and Teehans. The College of Arts and Sciences was made coeducational in 1968, breaking a 179-year tradition—but with only 50 positions made available for female students. That same year witnessed the formation of the Black Student Alliance and alumnus Bill Clinton's campaign for senior class president. Georgetown University was not immune to the hostile protests of the Vietnam War era, with a news photographer capturing a May Day demonstration broken up with tear gas. Lauinger Library was opened in 1970 and designed with the unfinished concrete aesthetics of the day, while the Law Center moved into McDonough Hall downtown.

With the completion of both the Intercultural Center and the Leavey Student Center in the 1980s, and a world-class athletic department creating headlines, Georgetown University was poised to take its place among the leading American universities of today.

The freshmen versus sophomore pushball game—a freshman hazing event—was photographed in the fall of 1958. This and other hazing rituals were discontinued in 1962 after alumnus Richard Heimbuch brought suit against Georgetown for a disabling injury he sustained during hazing. According to a 1961 *Washington Star* article, Heimbuch was injured as "a member of a group of freshmen who were compelled to move around campus in a 'elephant march' to an area where they were to be given a mud bath." (GU Archives.)

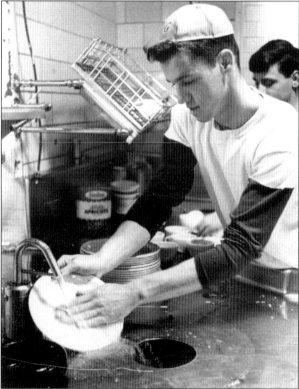

In lieu of physical hazing, students were assigned to community service projects. Here, student Don Vredenburgh (COL '66) rinses plates in front of a huge dishwasher at Georgetown Hospital. (MLK Library.)

The Georgetown Chimes were
founded in 1946 by Frank Jones
(LAW '48, LLM '52) as an
alternative to the campus Glee
Club. The a capella group
emerged as a Georgetown
institution. (GU Archives.)

As part of the nationwide Cold
War preparations, a mock disaster
drill was held at Georgetown
Hospital in 1960. (MLK Library.)

The Hilltop Café was located at 36th and N Streets and is pictured here prior to its 1962 conversion to The Tombs and 1789 restaurants. "No Better than the Best and Better than the Rest" was its slogan. Its specialties were advertised as filet mignon, hamburger steaks (smothered with onions), seafoods, and Budweiser beer on tap. (Bob Young, Jr./GU Archives.)

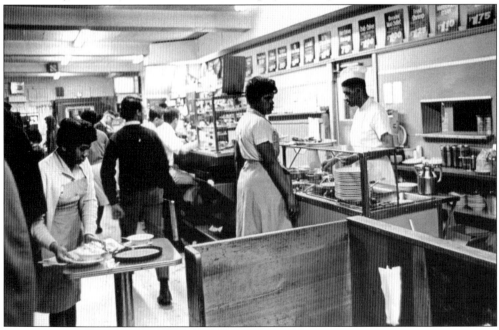

Teehans was a famous institution for generations of Georgetown students. It began in 1911 at 1232 36th Street as a small store with a soda fountain. (GU Archives.)

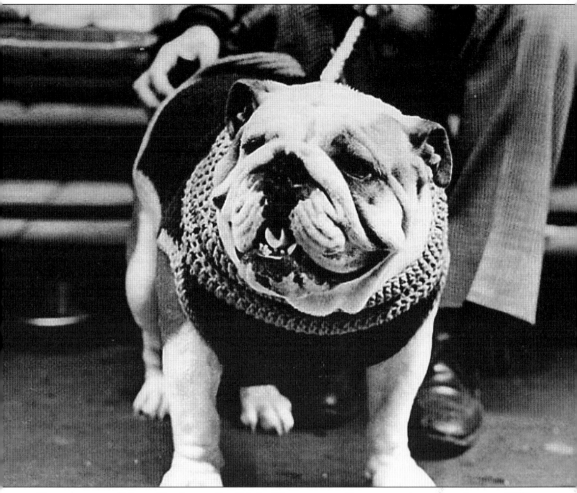

The current tradition of having an English bulldog serve as Georgetown's mascot dates to 1962 when a student committee led by Stan Samorajczyk (COL '64) decided that a purebred English bulldog would best exemplify the tenacious qualities of Georgetown athletes. After the University declined to fund their request for a live mascot, the committee raised funds through dances and solicitations, earning enough money to adopt "Jack I" for Georgetown. Jack I and his successors reigned through the 1960s, and in 1977, Georgetown began the tradition of a dog costume, rather than a live dog. (*Ye Domesday Booke.*)

The "norms and conduct of Georgetown gentlemen" for the 1965–1966 academic year were outlined in the annual "G-book." G-books from earlier in the century outlined specific rules for freshman students, including the directive that freshmen "will wear a distinctive cap everywhere on campus" and "will do any reasonable errand demanded of them by an upper classman." (GU Archives.)

The Black Student Alliance was started in 1968. According to the club's constitution, it was formed for the purpose of "reinstilling in ourselves that pride which has systematically been driven out of our ancestors and of educating both ourselves and members of the Georgetown University community." At the time only 40 black students attended Georgetown. (*Ye Domesday Booke*.)

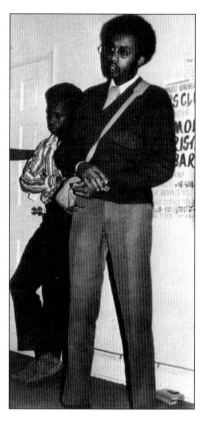

An emergency meeting of the East Campus Student Council was advertised for March 16, 1965, to discuss providing funds for "travel, bail or medical aid if necessary" for students traveling to Selma, Alabama, to participate in the historic marches against voter discrimination. (GU Archives.)

A REALISTIC APPROACH
TO
STUDENT GOVERNMENT

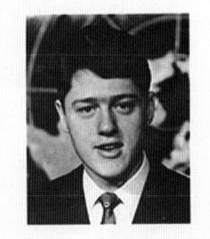

BILL CLINTON

CANDIDATE

PRESIDENT OF THE STUDENT COUNCIL

MAR. 8 1967

This campaign poster was used during Bill Clinton's (SFS '68) unsuccessful bid for election as president of the student council. It is not commonly known that Clinton was not first admitted to Georgetown, even though it was the only school to which he applied in 1964. *Georgetown* magazine recalled the following in 1986: "His admission had been delayed for months, and he had been turned down for a scholarship. When he finally arrived, Father Francis P. Dineen [S.J.] took one look at the freshman and wanted to know why in the world a Southern Baptist with no foreign languages wanted to come to Georgetown University, with intentions of majoring in international relations." Clinton replied, "I've thought about it, and this is where I want to be." (GU Archives.)

Dr. Patricia Rueckel, vice president for student development, is believed to be the first woman appointed as vice president of a Jesuit university—a curious distinction for Georgetown at a time when women were still prohibited from enrollment in the largest undergraduate school, the College of Arts and Sciences. (GU Archives.)

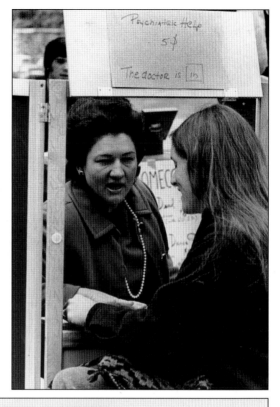

GEORGETOWN UNIVERSITY
SCHOOL OF FOREIGN SERVICE

FINAL EXAMINATION

Professor Quigley 20 May 1965
 DEVELOPMENT OF CIVILIZATION II

1. You may keep this sheet, but do not write on it.
2. Put your section and roll-number on upper-right corner of exam book.
3. Think out and outline your answer before you begin to write

QUESTION I
 Were the barbarian invasions a cause or a result of the fall of Rome?

QUESTION II
 How did the medieval kings build up their royal power?

QUESTION III
 "The late Middle Ages was a period of retrogression." Discuss.

In May 1965, Prof. Carroll Quigley, a legendary instructor who began teaching at Georgetown in 1941, posed three final-exam questions to students in his Development of Civilization II class. Quigley's concept of "future preference"—sacrificing in the present for future needs—was cited by Quigley's former student, Bill Clinton (SFS '68), in his speech accepting the Democratic Party nomination for president in 1992. (GU Archives.)

111

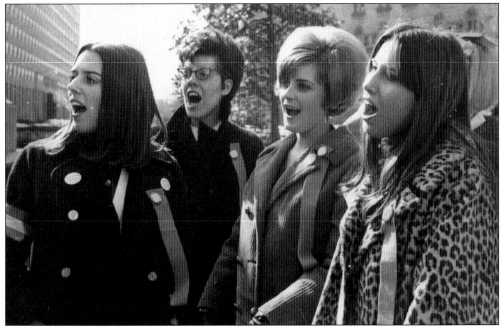

Developed as an "alternative to the revolution created by the leftist entity of the Students for Democratic Society (SDS)," the Square Power Conference held a 1969 rally at McPherson Square in Washington, D.C. Pictured singing "God Bless America" are Georgetown students (left to right) Joanne Harlan, Mary June Glorioso, Patsy Tedaro, and Scottie McGhan. (MLK Library.)

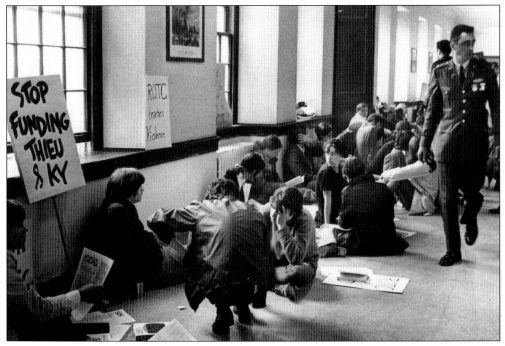

In April of 1969, students held a sit-in in the hall outside the offices of the Army Reserve Officers Training Corp (ROTC). At the right, an ROTC instructor ignores the protesters as he proceeds down the hall. (MLK Library.)

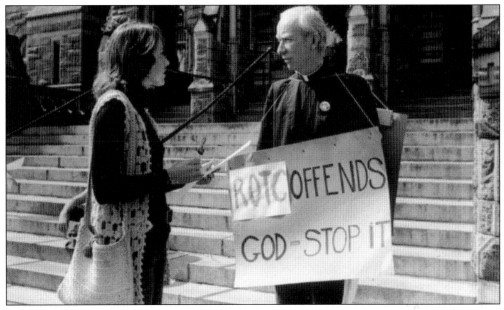

Fr. Richard McSorley, S.J., founder of the Center for Peace Studies at Georgetown, demonstrated in 1971 against the presence of the Army Reserve Officers Training Corp (ROTC) on campus. Advocating non-violent solutions to world problems, McSorley had a long arrest record for protests. So popular were his classes in peace studies that students would overflow the classroom and often take the course for no credit. (GU Archives.)

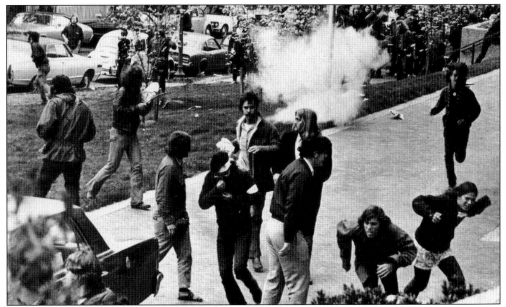

This photograph was taken on May 3, 1971, as police fired tear gas outside Lauinger Library to disperse protesters who had descended onto campus to seek shelter during the May Day disturbances. Days later, students protesting the university's response occupied the hallway outside the president's office in Healy Hall and were suspended by Pres. Robert Henle, S.J., (1969–1976) when they refused to leave. (*Georgetown University, A Pictorial Review*/GU Archives.)

Women have studied at Georgetown continuously since the founding of the School of Nursing in 1903—and all schools *except* the College of Arts and Sciences admitted women after 1953. Not until a 1968 Board of Directors decision did the College of Arts and Sciences make a transition to co-education. (*Ye Domesday Booke*.)

The Hoya

Vol. LI, No. 21 GEORGETOWN UNIVERSITY, WASHINGTON, D.C.

College May Admit Girls; Student Opinions Sought

Coeds might well be admitted to the all-male College of Arts and Sciences come September of 1969. The College's faculty has informally agreed to the proposal, but students and alumni are yet to be consulted. If reaction is favorable, a study will be conducted during the summer to ascertain the effect of an increased College enrollment on classroom and dormitory space and student

ward it to the University Board of Directors.

According to the Rev. Thomas R. Fitzgerald, S.J., academic vice president, "a reasonable amount, not just a handful" of girls would be admitted to the Class of '73, perhaps 50 to 100. He noted that discussion is being taken up at this point so that the admissions office would have ample time in which to process applications. Fr.

luding February's tuition increase controversy, he remarked, "In no sense are we going to say, 'This is what we've done.' " He added "We will also have the alumni to cope with."

The Rev. Royden B. Davis, S.J., College dean, indicated that he and Fr. Fitzgerald had discussed the possibility of College coeds for some time. Fr. Davis brought up the question to his executive

On May 2, 1968 *The Hoya* carried news that Georgetown "may admit girls" to the College of Arts and Sciences for the first time starting in the fall of 1969. The eventual decision to enroll women broke a 179-year-old practice of males-only in the College. That year the Admissions Office was flooded with over 500 applications for only 50 available female spots. (*The Hoya*.)

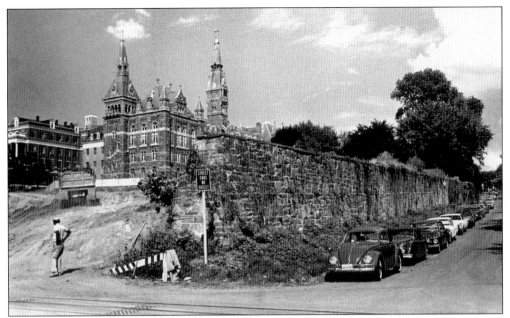

The future site of Lauinger Library is seen here along with a section of the 19th-century stone wall that once ran uninterrupted from Healy Gates to the corner of 37th and Prospect Streets. Built at a cost of $6.6 million, the facility was named for Joseph Mark Lauinger, a 1967 alumnus killed in the Vietnam War, at its opening in 1970. (GU Archives.)

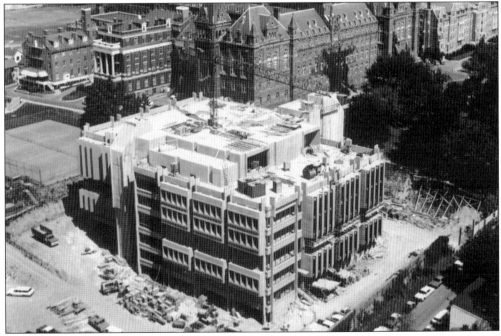

This picture, taken in 1969, shows Lauinger Library under construction. Designed by John Carl Warnecke, the library was built of dark gray pre-cast concrete with a wide variety of windows and sound control devices, which gave the building a richly textured facade designed to complement the ornate turrets and decorations of Healy Hall. (GU Archives.)

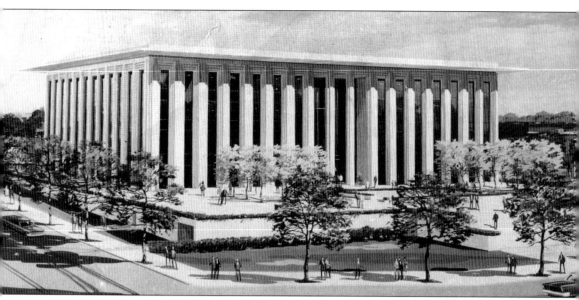

Kennedy Center architect Edward Durell Stone designed McDonough Hall as a new home for the Law Center. Located at 600 New Jersey Avenue N.W., the building's original design, which called for a marble facade, was substantially altered due to cost cutting (white bricks were used instead). The building was named for Bernard P. McDonough, a 1925 graduate of the Law School, and his $1 million gift was then the largest ever received by the university. (MLK Library.)

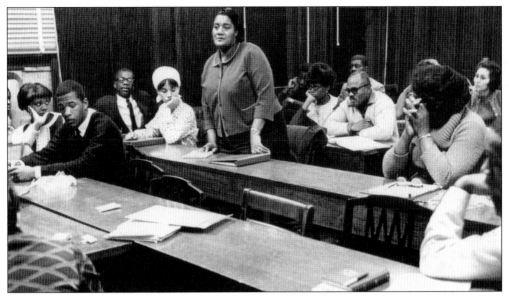

In 1967, the Law Center launched what was called the "New College for the Poor." Twenty-nine persons whose formal education averaged out to the junior year of high school enrolled in the program. (MLK Library.)

Middle-distance runner Rick Urbina (pictured at left) runs with Bob Zieminski in 1967. Urbina (COL '67, LAW '70) earned All-America honors in track three times, as well as a national middle-distance track championship. He was President Ronald Reagan's first judicial appointee and the first Hispanic ever appointed to the District of Columbia bench. (MLK Library.)

Responding to tuition increases announced in 1973, Georgetown University students joined Edmund G. Ryan, S.J., in dumping thousands of fresh lemons outside the office of Pres. Robert Henle, S.J. Best known off-campus as the university's spokesman on matters relating to exorcism, Ryan was later fired by Henle without public explanation, sparking a series of student protests. (MLK Library.)

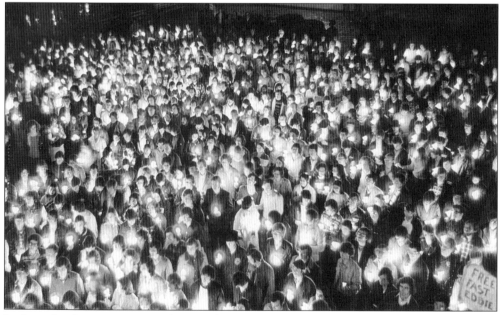

In the style of a war protest, students seeking an explanation for the 1974 termination of Father Ryan gathered in the Quadrangle for a candlelight vigil. A sign visible in the bottom right corner of the photograph pleads "Free Fast Eddie." (MLK Library.)

118

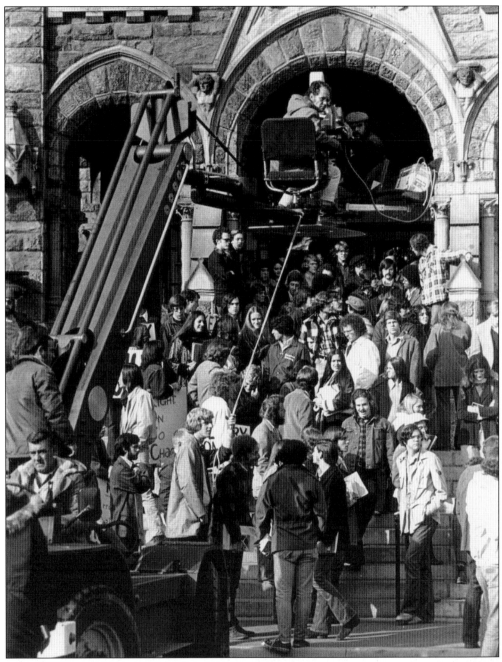

The filming of the 1973 movie *The Exorcist* took place on campus in the fall of 1972. The film's producer, William Peter Blatty (COL '50), based his story on the actual exorcism of a 14-year-old boy from Mt. Ranier, Maryland. The boy, whom Blatty disguised in his novel as 12-year-old Regan MacNeil, was reported by *The Washington Post* on August 19, 1949, to have been treated at Georgetown Hospital during and after the exorcism ritual, which was conducted between 20 and 30 times over a two-month period in Washington, D.C. and St. Louis, Missouri. (GU Archives.)

Founded in 1972, Students of Georgetown, Inc. (the Corp) is a private, nonprofit business operated by students independent of the university administration. The Corp's first store, Vital Vittles, was opened in 1974 and operated for many years in the basement of Healy Hall. (*Ye Domesday Booke*.)

Friday, November 11, 1977

ad
rity
cern

McAleer
ing occurence of
npus this year,
Quad, student
llagher and Jim
d for increased
forts.
ery occurred last
aguire, when an
he Quad through
r on 4th Healy,
n jewelry.

BONGS

SUPER STASH $5.25
SCREAMER $7.25
KILLER $8.00
ALUMINUM "LYNCH" $10.50
SMOKER $6.50
IMPERIAL $5.75
TALL GLASS ODYSSEY $5.75

photo by John Gilvar

Vital Vittles has recently begun selling bongs.

Over the years, the Corp tested the limits of university code by selling controversial items on campus. In the 1970s, these water pipes, or "bongs," were advertised for sale and were at the center of disagreement between students and administrators. (*The Hoya*.)

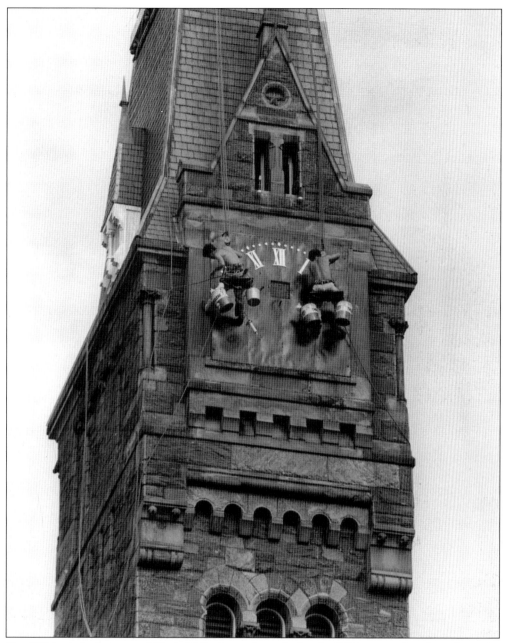

The 200-foot clock tower of Healy Hall, shown here during its 1983 restoration, is perhaps the most visible symbol of the Georgetown campus. The tower contains three bells named for St. Aloysius Gonzaga, St. Maria and St. Sedes Sapientiae, and St. Joannes Berchmans. Until the tower was wired with alarms, the hands of the clock were often stolen by students, and a 1980s issue of *The Hoya* even provided a detailed description of how to gain access to the tower. (GU Archives.)

In 1979, Marquesa Margaret Rockefeller de Larrain, the only living granddaughter of John D. Rockefeller, donated to Georgetown her mansion in the hilltop town of Fiesole overlooking Florence, Italy. Named Villa le Balze ("cliff house"), the three-acre estate was developed as a conference center and for overseas studies in fine arts, classics, Italian, and history. (*Georgetown* Magazine.)

The Edward B. Bunn, S.J. Intercultural Center was completed in 1982. A successful case for Congressional funding for an "intercultural center" at Georgetown was linked to post–Vietnam War concerns that recent foreign policy failures were related to deficiencies in American education—specifically a lack in foreign language education and knowledge of international affairs. An additional level of Congressional funding was secured when the university agreed to include what was then the world's largest solar roof in the building's design. (GU Archives.)

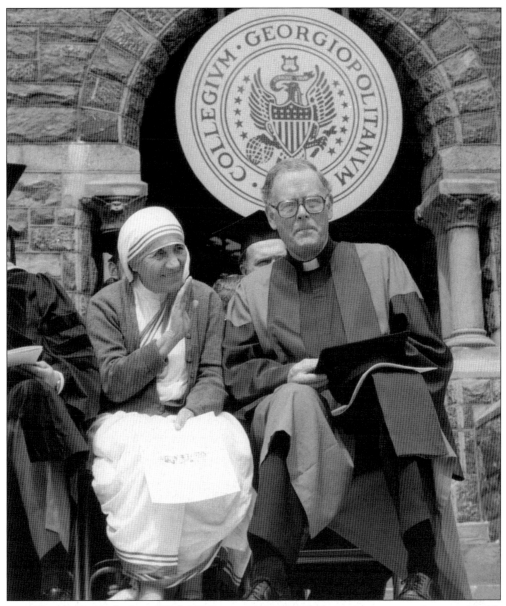

Pres. Timothy S. Healy, S.J., (1976–1989) appears in this 1982 commencement photograph with honorary degree recipient Mother Teresa of Calcutta. Healy, not related to the Patrick Healy of the 19th century, was the longest-serving president in Georgetown's history. During Healy's tenure, student housing complexes Villages A and C and Alumni Square were built, as well as the Intercultural Center, Yates Field House, the Edward Bennett Williams Law Library, and the Leavey Student Center. Undergraduate admission rates went from 44 percent in 1976 to 23 percent in 1989; minority enrollment increased from 6 percent to 19 percent; and the Hoyas won their first-ever national basketball championship. Moreover, Healy set out to address Georgetown's woeful financial standing. Fund-raising campaigns during his tenure raised the endowment fivefold. Healy was also at the center of sharp debate over Georgetown's position as the nation's oldest Catholic university and over its relations with the District of Columbia and Federal governments. (GU Archives.)

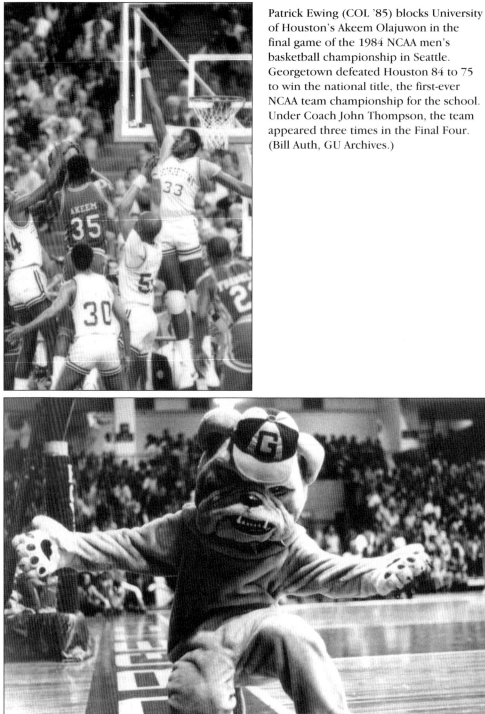

Patrick Ewing (COL '85) blocks University of Houston's Akeem Olajuwon in the final game of the 1984 NCAA men's basketball championship in Seattle. Georgetown defeated Houston 84 to 75 to win the national title, the first-ever NCAA team championship for the school. Under Coach John Thompson, the team appeared three times in the Final Four. (Bill Auth, GU Archives.)

In 1977, Georgetown began the tradition of using a dog costume in place of an actual English bulldog for a team mascot at sporting events. Pat Sheehan (COL '81) was the first student to play the role. (*Ye Domesday Booke.*)

The Law Center campus was greatly enhanced in 1989 by the addition of the Edward Bennett Williams Law Library. Williams was a 1944 graduate of the Law School and worked for more than four decades as Georgetown's legal counsel. Williams was a renowned trial lawyer, defending clients such as Sen. Joseph McCarthy, Jimmy Hoffa, and John Hinkley. (*Georgetown* Magazine.)

Georgetown completed the Thomas and Dorothy Leavey Student Center in 1988. Designed to reflect the Victorian romanticism of 1879 Healy Hall, the Leavey Center was strategically located to mediate between the institutional architecture of the medical complex and the finer textures of the historic campus. It was the first of several "podium" buildings planned to slope downward toward the south. (GU Archives.)

The United States Postal Service recognized the historic landmark status of Healy Hall by issuing a postal card in January 1989. In 1988, the United States Department of the Interior had designated Healy as a national historic landmark and placed it on the National Register of Historic Places. The drawing of Healy is by Georgetown alumnus John Morrell (COL '73). (GU Archives.)

President Ronald Reagan was awarded an honorary degree at Georgetown's bicentennial convocation on Healy Lawn. Reagan was introduced by Georgetown Prof. Jeane Kirkpatrick, whom Reagan appointed as United States Permanent Representative to the United Nations, the first woman to ever hold that post. (GU Archives.)

A bicentennial logo—derived directly from the university seal—was created in 1989 to celebrate Georgetown's 200th year. At the center of the seal is an oak branch, signifying strength, crossed by a laurel branch, signifying peace and victory. Both pointed to Georgetown's founding year and its bicentennial year. Framing the shield were the words "Learning, Faith, and Freedom," representing "the missions and ideals that have always guided Georgetown." (GU Archives.)

BIBLIOGRAPHY

Ballman, Francis X. *Building Outlines: Campus Buildings, 1789–1995*. Washington, D.C.: Georgetown University Archives, unpublished manuscript, 1995.

Curran, Robert Emmett. *The Bicentennial History of Georgetown University: From Academy to University, 1789–1889 Vol. I*. Washington, D.C.: Georgetown University Press, 1993.

Daley, John M., S.J. *Georgetown University: Origin and Early Years*. Washington, D.C.: Georgetown University Press, 1957.

Durkin, S.J., Joseph, editor. *Swift Potomac's Lovely Daughter: Two Centuries at Georgetown through Student's Eyes*. Washington, D.C.: Georgetown University Press, 1990.

Durkin, S.J., Joseph T. *Georgetown University: First in the Nation's Capitol*. Garden City, New York: Doubleday and Company, 1964.

Editor. *A Pictorial Review: Georgetown Past and Present (Sesquicentennial Year 1789–1939)*. Washington, D.C.: Georgetown University, 1939.

Ernst, Daniel R. *The First 125 Years: An Illustrated History of the Georgetown University Law Center*. Washington, D.C.: Georgetown University Law Center, 1995.

Gallagher, Rev. Louis J., S.J. *Edmund A. Walsh, S.J.* New York: Benzinger Brothers, Inc., 1962.

Mitchell, Mary. *Divided Town: A Study of Georgetown, D.C. During the Civil War*. Barre, Massachusetts: Barre Publishers, 1968.

McEvitt, William G. *The Hilltop Remembered*. Washington, D.C.: The Georgetown University Library, 1982.

Reynolds, Jon K., and Barringer, George M. *Georgetown University, A Pictorial Review*. Baltimore, Maryland: The Charles B. DeVilbiss Company, 1976.

Shea, John Gilmary, S.J. *History of Georgetown University in the District of Columbia*. Washington, D.C.: Georgetown University Press, 1981.

Tillman, Seth P. *Georgetown's School of Foreign Service: The First 75 Years*. Washington, D.C.: Georgetown University Press, 1994.